MENSWEAR DOG

— PRESENTS —

THE NEW CLASSICS

MENSWEAR DOG
— PRESENTS —

THE NEW CLASSICS
FRESH LOOKS FOR THE MODERN MAN

DAVID FUNG & YENA KIM

ARTISAN

NEW YORK

Library of Congress Cataloging-in-Publication Data
Fung, David 1984–
 Menswear Dog presents : the new classics : fresh looks for the modern man / David Fung and Yena Kim.
 pages cm
 ISBN 978-1-57965-616-4
1. Mens' clothing. 2. Clothing and dress—Miscellanea. 3. Fashion photography. 4. Photography of dogs. I. Kim, Yena. II. Title. III. Title: New Classics. IV. Title: Fresh looks for the modern man.
 TT617.F86 2015
 779'.329772—dc23 2014035877

Design by Topos Graphics

Artisan books are available at special discounts when purchased in bulk for premiums and sales promotions as well as for fund-raising or educational use. Special editions or book excerpts also can be created to specification. For details, contact the Special Sales Director at the address below, or send an e-mail to specialmarkets@workman.com.

Published by Artisan
A division of Workman Publishing Company, Inc.
225 Varick Street
New York, NY 10014-4381
artisanbooks.com

Published simultaneously in Canada by Thomas Allen & Son, Limited

Printed in Singapore
First printing, March 2015

10 9 8 7 6 5 4 3 2 1

CONTENTS

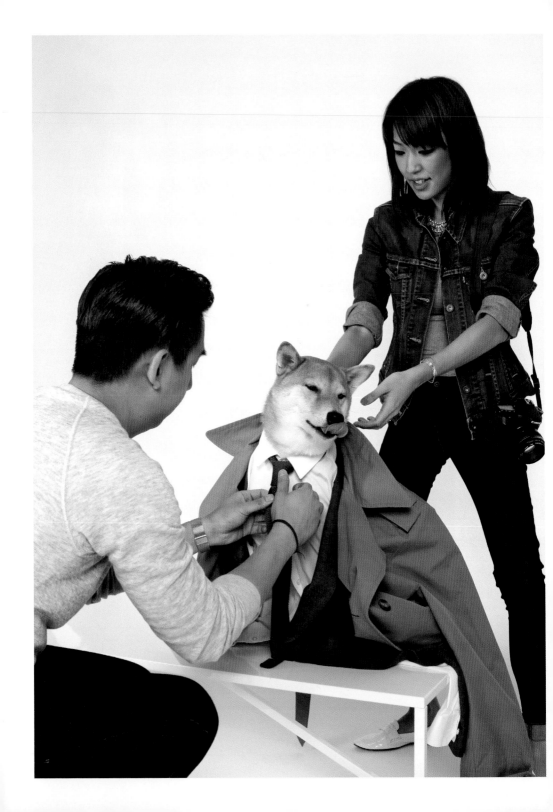

INTRODUCTION

The idea for Menswear Dog came about very simply. In January 2013, we snapped a photo of our handsome Shiba Inu, Bodhi, in a chunky shawl-collar cardigan and posted the photo to Facebook, thinking we'd elicit a few giggles. This one photo of our dog got more likes from our friends and family than we had ever gotten on both of our accounts combined. Invigorated by this pet project (lame pun intended), we put together a Tumblr blog with a few more photos of our canine dressed to impress and unleashed it for the world to see. The site took off, and our in-box started to fill with notifications as Bodhi's pictures were shared all over the Internet by pet lovers and fashionistas alike. What began as an inside joke was being seen by tens of thousands of people.

It was a simple concept, executed a thousand times over by every weird pet owner with a little too much time on their hands. So what made people sit up and pay attention this time around? Credit where credit's due, Bodhi is a looker—with a piercing gaze, a glistening wet nose, and a smile that could light up Broadway, all he needed was some peanut butter to realize his true calling. His personality comes through in every photo, and he has a natural ability to sense which poses to strike and how to work every angle. Bodhi's innate modeling talents brought new life to something we already loved

and obsessed over: menswear. We decided to put our years of design experience (in fashion and graphic design, respectively) into an intimate menswear photo project—we figured if nothing else, it would make a great story.

What started as a parody is now the real deal. Menswear Dog has become a unique avenue to showcase men's fashion in an unexpected yet approachable way (after all, if a dog can pull it off, you can too).

It's with this spirit that we wrote the book—a guide to the hardworking items that act as the backbone for a timeless and versatile wardrobe. We've mixed in classic heritage pieces with current menswear so you can build your wardrobe according to your own evolving taste and budget. And each featured item includes styling and layering advice to ensure you'll have a winning look for any occasion. Job interview? Weekend getaway? Invitation to a summer wedding? Dog's got your back. There's advice on when to splurge and when to save, how to get the right fit, the brands and shops every guy should know, the basics of clothing care, and more.

Now go out there and try things on! And remember, at the end of the day, fashion should make you happy. Look your best and have fun doing it—Menswear Dog sure does.

1

Invest now; save later.

———

2

Classics are timeless
for a reason.

———

3

Find yourself
a good tailor.

———

4

Fit trumps price every time.

———

5

Take care of your clothes.

6

Clothes should be fitted,
never tight.

———

7

It's okay to copy your fashion idols.

———

8

Learn how to properly tie a tie.
(Need help? See page 139.)

———

9

When in doubt, keep it simple.

———

10

If it doesn't make you feel good,
don't wear it.

SPRING

Spring is the season of renewal; flowers are in bloom and everyone is feeling lighter and brighter. It's also a season with unpredictable weather, so building a solid and versatile wardrobe is crucial. From floral shirts to raincoats, here's what you should incorporate into your spring lineup.

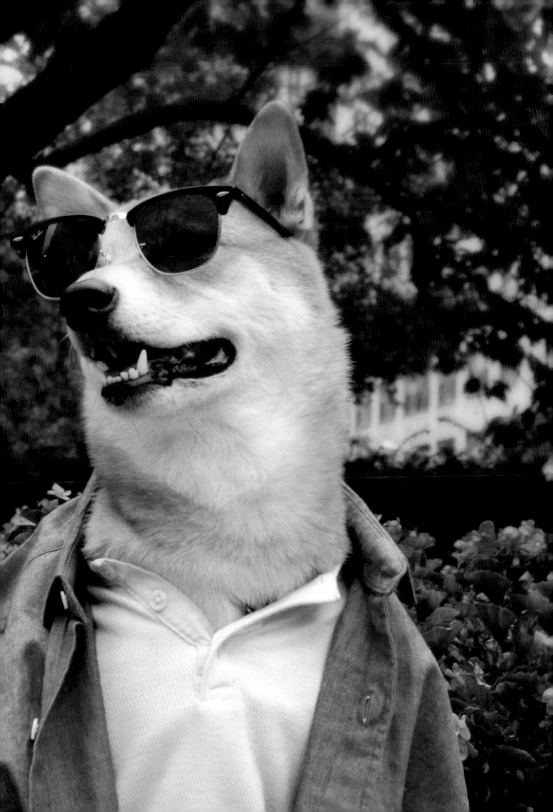

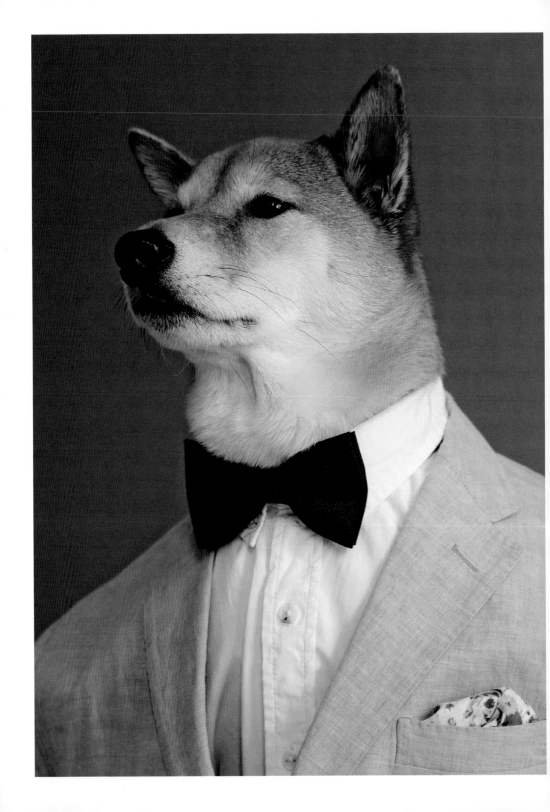

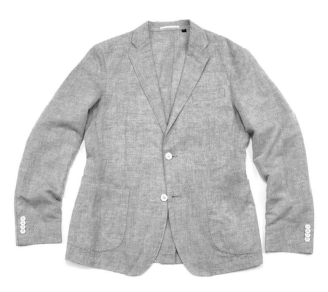

PALE SUIT JACKET

The unofficial rule of menswear is that you can never go wrong with neutrals, but you've been hibernating all winter—it's time to celebrate. A spring suit jacket is the perfect place to take risks with color. Salmon (shown here), pale blue, and cream are all options; just be sure to choose hues that contrast with your skin tone. The key to pulling off a colorful suit jacket successfully is to keep everything else muted and let the jacket do most of the talking.

TRY IT WITH

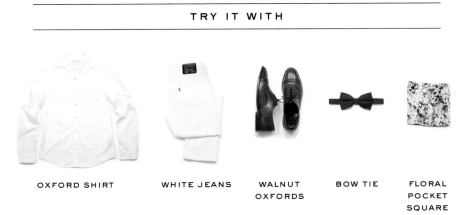

OXFORD SHIRT WHITE JEANS WALNUT OXFORDS BOW TIE FLORAL POCKET SQUARE

STAYING POWER

The tried-and-true Levi's Original remains the best-looking—and one of the most affordable—denim jacket options out there. Look for the iconic red tab on the chest pocket and you'll know you've got a sure thing.

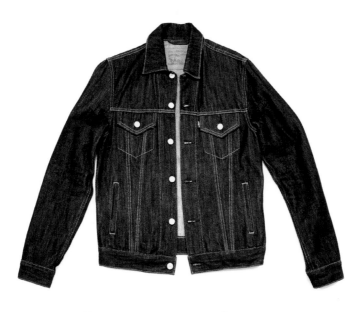

DENIM JACKET

The denim jacket was invented by Levi Strauss & Co. in the early 1900s as a heavy, durable work shirt for Gold Rush miners and cowboys in the Wild West and has evolved into the denim trucker jacket that we all know and love today. Dark and medium blue shades can be layered under dark suits for added warmth when it gets chilly, and light shades work well with neutral-colored casual wear. Beware the "Canadian tuxedo" look—never pair your jacket with denim jeans in the same color or wash. Khakis or wool trousers are great options, as are black or white denim jeans.

TRY IT WITH

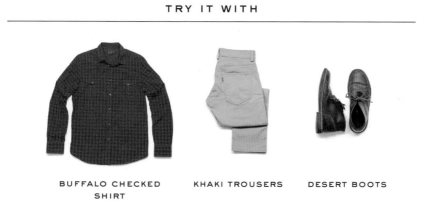

BUFFALO CHECKED KHAKI TROUSERS DESERT BOOTS
SHIRT

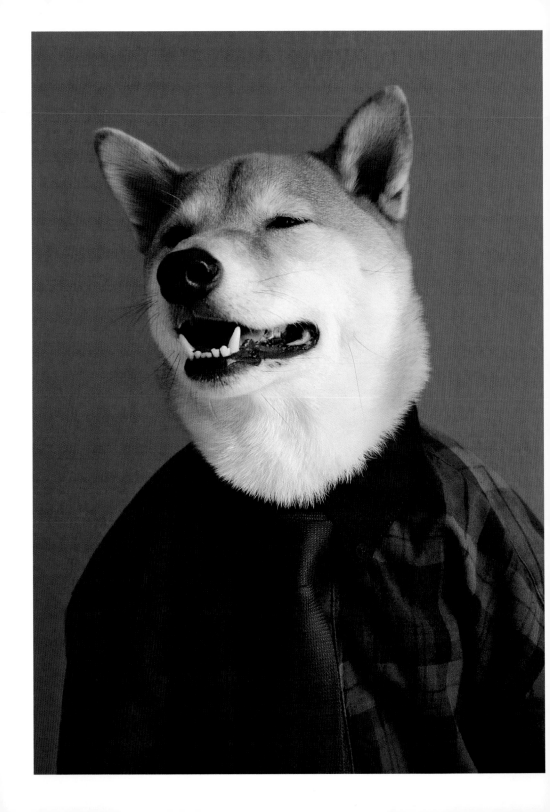

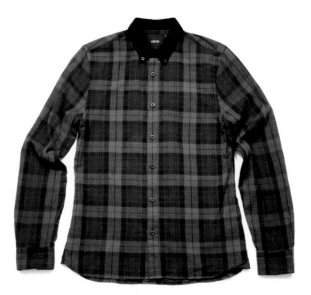

TARTAN SHIRT

Tartan describes plaid patterns, woven in wool, that were worn by the Scots as early as the sixteenth century to identify their clans. In 1746, tartan became exclusive to regiments within the English army, and this association continued well into the 1970s, when punks tore up tartan shirts and paired them with "God Save the Queen" T-shirts to demonstrate discontent with authority. Tartan shirts are now a staple on the runway thanks to designers like Thom Browne, Raf Simons, and Alexander McQueen, and they should be a staple in your closet as well—whether you decide to go posh with a slim tie and crisp trousers or punk with black denim and work boots.

TRY IT WITH

BLACK TROUSERS

DOUBLE MONK STRAPS

BLACK TEXTURED TIE

DID YOU KNOW?

The first hooded sweatshirt was made by Champion in 1934 to protect laborers and outdoor workers from the cold.

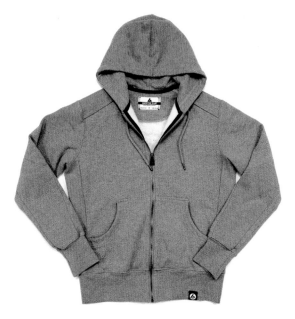

HOODED SWEATSHIRT

When you're dealing with an item as ubiquitous as a hoodie, the devil really is in the details. It all comes down to the fabric, color, and fit. Opt for breathable cotton or a cotton blend. Soft heather gray simply cannot be beat. And reserve the oversized hoodie for when your girlfriend stays over—get the size right and make sure it hugs your body, not your hips. Whether you wear it on its own or under a denim jacket, you'll look like you're ready to go ten rounds, no sweat.

TRY IT WITH

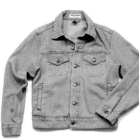

STRIPED BRETON SHIRT

DENIM JACKET

BLACK JEANS

WHITE TENNIS SHOES

AT THE GYM

A lot of guys choose their workout apparel as if every day is laundry day, throwing on whatever isn't dirty. But isn't looking good the point of hitting the gym? Here's the key to working it while working up a sweat.

DO

Look for active performance fabrics that help you keep cool and stay dry

Opt for dark-colored fabrics that hide sweat stains

Invest in a bulk pack of plain T-shirts

Throw away all clothes with visible sweat stains

Layer with a gray heather hoodie if it gets cold out

DON'T

Wear sandals, dress shoes, or boots

Try to pull off a nipple-exposing tank

Wear anything skintight

Wear jeans

Leave on your heavy, expensive watch or excessive jewelry

THREE WINNING COMBOS

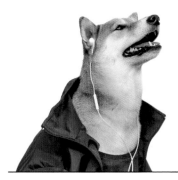

RUNNING

Plain crew neck T-shirt, black
running shorts, running shoes,
Windbreaker (if needed)

LIFTING

Dark sleeveless T-shirt, tapered
joggers, trainers

BASKETBALL

Plain crew neck T-shirt, gray heather
hoodie, basketball shorts, sneakers

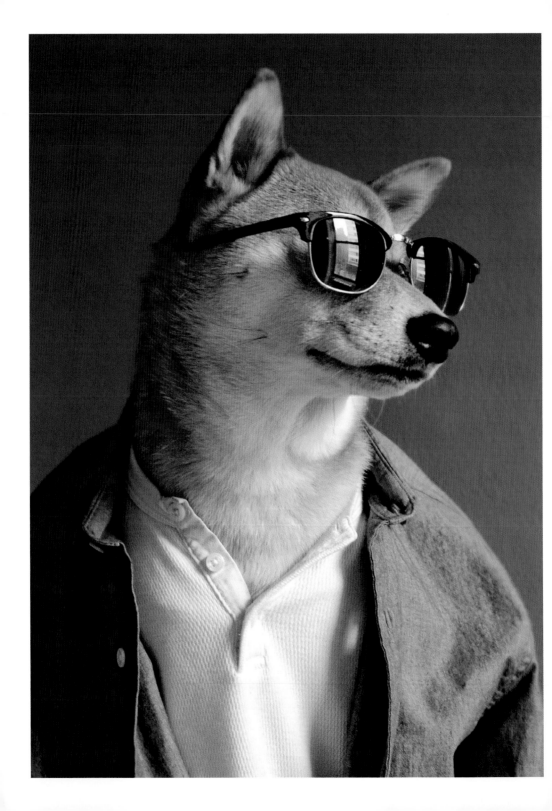

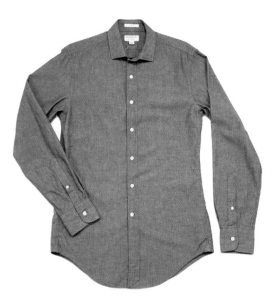

CHAMBRAY SHIRT

Unlike its hefty cousin denim, lightweight chambray is thin enough for layering and soft to the touch. The beauty of a chambray shirt is that it can dress down very easily as a casual work shirt over a T, or it can be elevated to add contrast under a suit jacket and tie. It boldly goes where your denim jacket was too bulky to go before.

TRY IT WITH

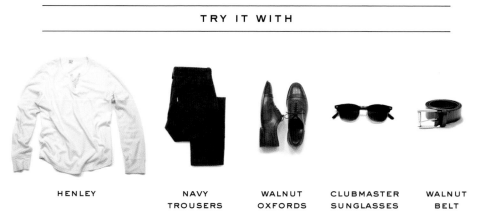

| HENLEY | NAVY TROUSERS | WALNUT OXFORDS | CLUBMASTER SUNGLASSES | WALNUT BELT |

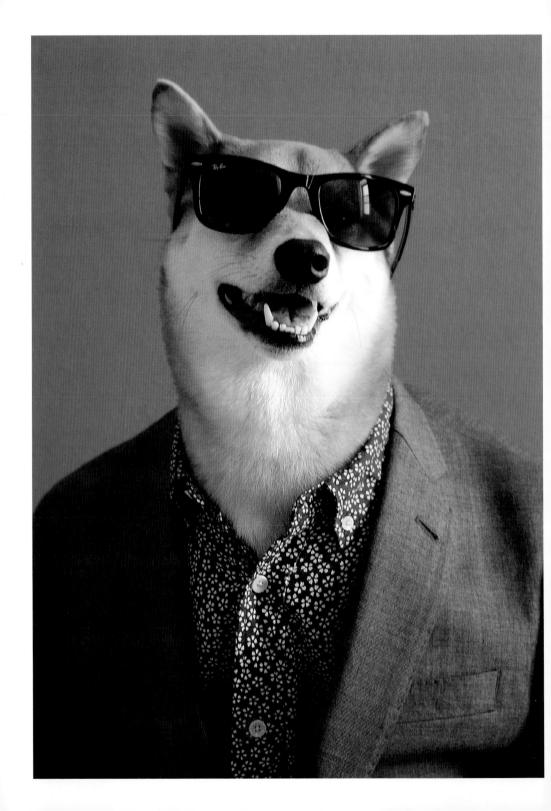

FLORAL SHIRT

The arrival of slim-fit long-sleeved floral shirts from brands like Givenchy, Prada, and Paul Smith means florals are now a serious contender in the world of printed shirts for men. Avoid looking over-the-top by choosing smaller-scaled designs—they will seem like textures or allover prints from afar. And as with any other busy pattern, keep the rest of your outfit muted for a good balance.

TRY IT WITH

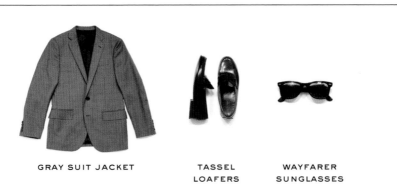

GRAY SUIT JACKET TASSEL LOAFERS WAYFARER SUNGLASSES

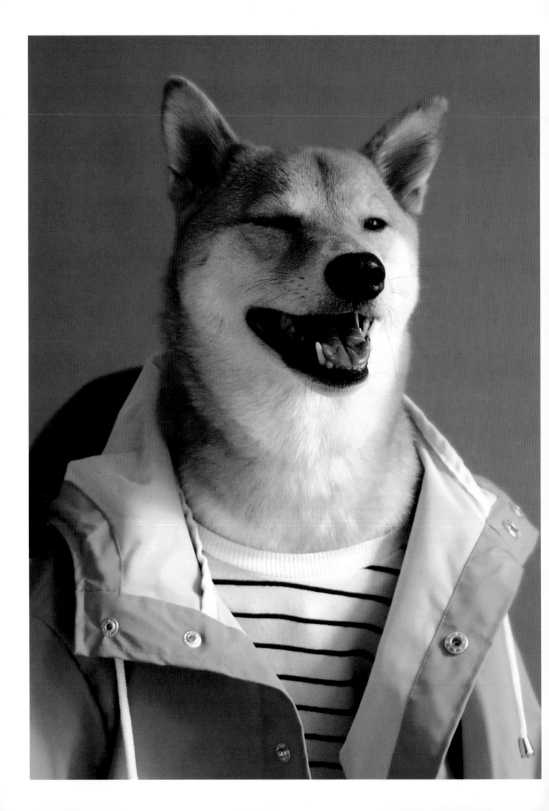

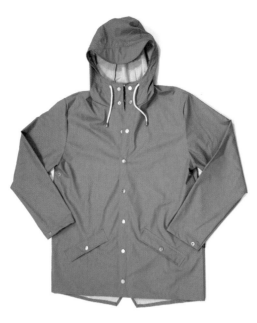

RAINCOAT

Don't be that guy who shows up at the office drenched in rain, gingerly drying his shirt with the bathroom hand-dryer. Do yourself (and your clothes) a favor and invest in a good-looking and functional raincoat. A proper raincoat, or "slicker," should have a hood, be constructed of a moisture-wicking fabric, and end around mid-thigh. Don't be afraid to go bright—you might as well look cheerful while you're battling Mother Nature.

TRY IT WITH

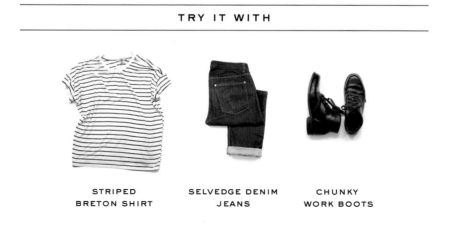

STRIPED BRETON SHIRT SELVEDGE DENIM JEANS CHUNKY WORK BOOTS

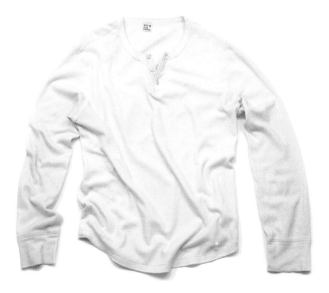

HENLEY

A Henley is essentially a crew neck T-shirt that features a front placket with buttons and a round neckline. Long associated with team sports and manual labor, it lends a charming old-school ruggedness to any outfit. It's great for layering and can work as an undershirt when you need added warmth, yet it's substantial enough to stand alone with a pair of jeans. Henleys come in short- and long-sleeved versions and should fit just like your perfect T (see page 142). Leave it untucked to keep things casually chic.

TRY IT WITH

TWEED BLAZER **BLACK TROUSERS** **TASSEL LOAFERS** **GINGHAM POCKET SQUARE**

THE GLOBE-TROTTER

There's something undeniably appealing about a well-traveled man; he has backpacked his way around the world and has a wealth of experience—and style—to show for it. He goes for pieces that are simple, functional, and comfortable, and his pared-down wardrobe is appropriate for almost every occasion.

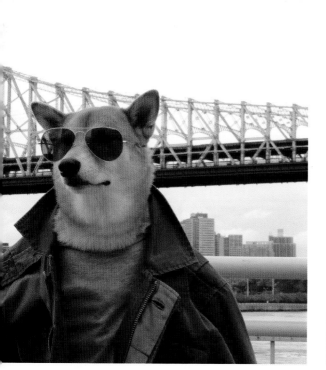

11

TRAVEL-READY
MUST-HAVES

1. White or gray T
2. Linen shirt
3. Henley
4. Crew neck sweater
5. Dark jeans
6. Khaki trousers
7. Desert boots
8. Military field jacket
9. Brown fedora
10. Aviator sunglasses
11. Scarf

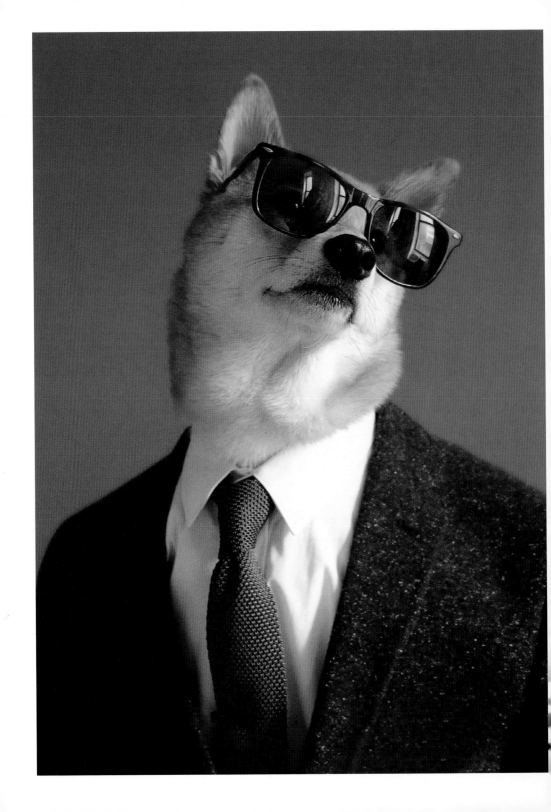

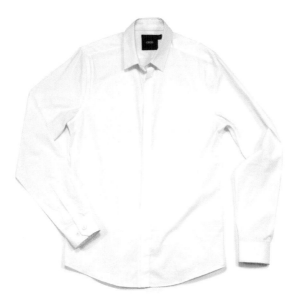

WHITE DRESS SHIRT

The classic white dress shirt needs no introduction—it is the glue that holds ensembles together, and one of the most versatile items in a gentleman's wardrobe. When in doubt, reach for this crisp blank canvas. Wear it under any suit, regardless of color, weight, or texture, or with a pair of dark blue jeans sans jacket for a more relaxed outfit. You're sure to get mileage from this piece, so don't be afraid to make an investment.

TRY IT WITH

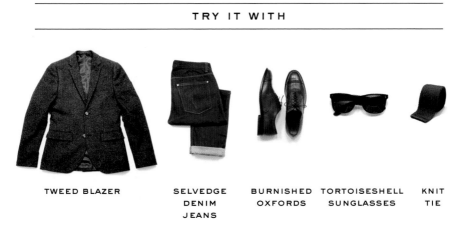

| TWEED BLAZER | SELVEDGE DENIM JEANS | BURNISHED OXFORDS | TORTOISESHELL SUNGLASSES | KNIT TIE |

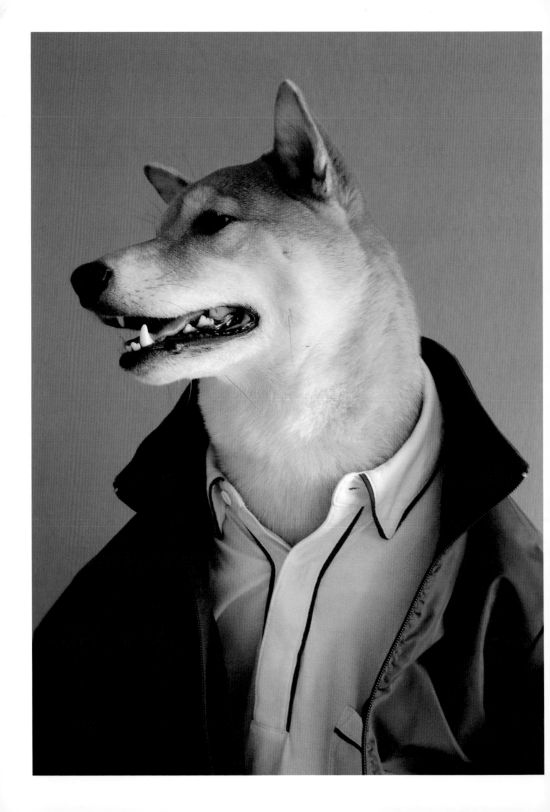

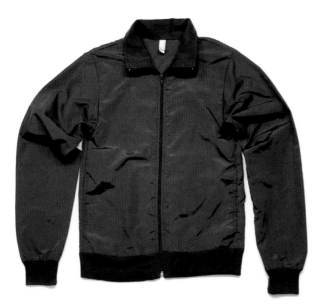

WINDBREAKER

A Windbreaker is exactly what it sounds like—a thin outer coat engineered to resist light rain and windchill. Typically made from synthetic material, it's lightweight enough to stuff into your travel bag if the weather is iffy. Nail the fit or you'll risk looking like you're off to play bingo; find an updated style with fitted sleeves and a shorter crop that ends right at your hips.

TRY IT WITH

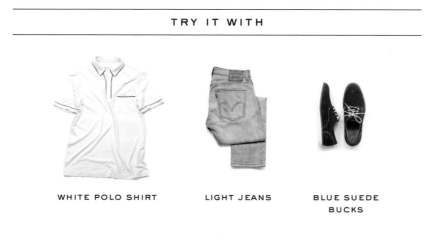

WHITE POLO SHIRT LIGHT JEANS BLUE SUEDE
 BUCKS

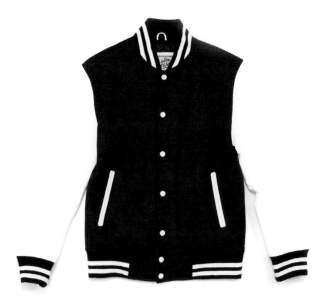

VARSITY JACKET

With a slimmer cut and much higher quality materials than your typical high school fare, the modern varsity jacket is no longer reserved for the football team. This preppy standard has been adopted by streetwear culture, where it's paired with the newest brogues and sneakers alike. If you can afford it, invest in one with real leather sleeves and you'll be ready to rally.

TRY IT WITH

GINGHAM SHIRT

CREW NECK
SWEATER

KHAKI
TROUSERS

WHITE TENNIS
SHOES

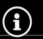

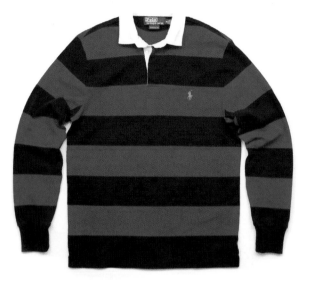

RUGBY SHIRT

Sporting life has always been a source of style inspiration, with designers taking cues from athletic uniforms since the 1950s. Much like the polo, the rugby shirt has become a preppy calling card—and it layers just as well, with the added interest of a stiff white collar and bold colored stripes. The beauty of the rugby shirt is that you don't have to overthink it. Throw it on with a pair of chinos and you're ready for the weekend, or wear it under a sport coat for an unconventional way to get a little fancy.

TRY IT WITH

SELVEDGE
DENIM JEANS

BURNISHED
OXFORDS

BURNISHED
BELT

SPRING ESSENTIALS

1. Chambray shirt
2. Tartan shirt
3. Floral shirt
4. White dress shirt
5. Henley
6. Rugby shirt
7. Hooded sweatshirt
8. Pale suit jacket
9. Denim jacket
10. Varsity jacket
11. Raincoat
12. Windbreaker
13. Khaki trousers
14. Tassel loafers
15. Burnished or walnut oxfords
16. Clubmaster sunglasses

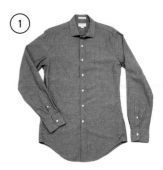

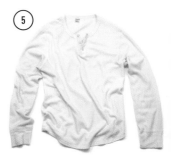

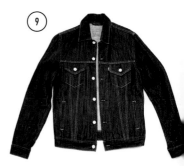

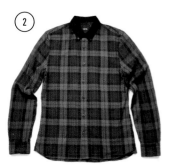

2

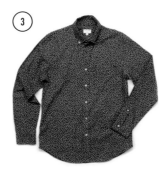

3

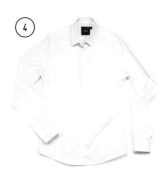

4

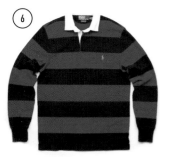

6

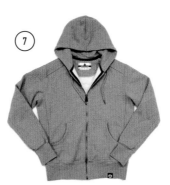

7

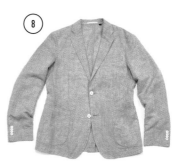

8

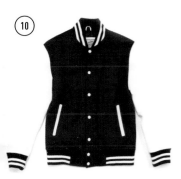

10

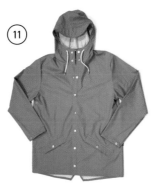

11

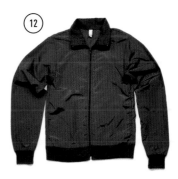

12

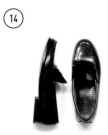

14

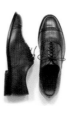

15

16

SUMMER

—

While the heat can be a great excuse to dress more casually, don't throw all the style rules out the window—there are ways to stay cool and fashionable at the same time. From linen suits to the perfect T, here are the pieces that will keep you looking slick all summer long.

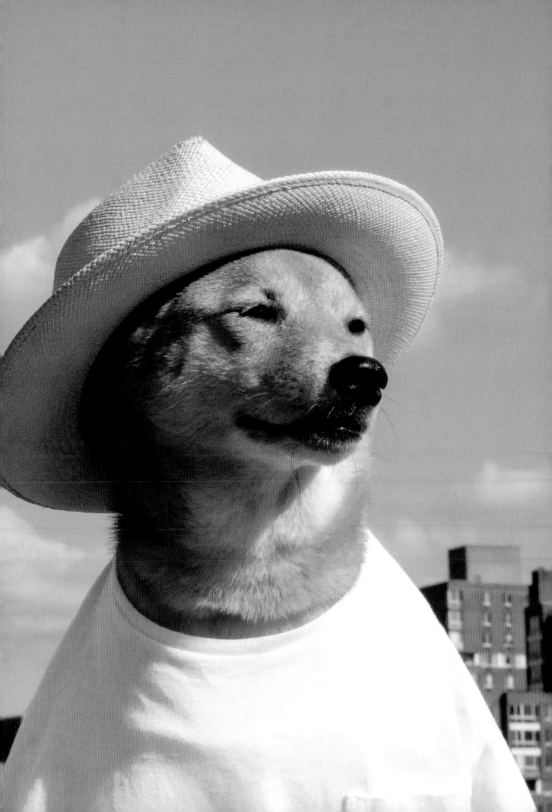

STAYING POWER

The polo shirt was created by René Lacoste, a French tennis champion who wanted a more comfortable, breathable alternative to the button-down shirts that were typical of his sport. His design, complete with the iconic embroidered alligator, has been in production for nearly a century.

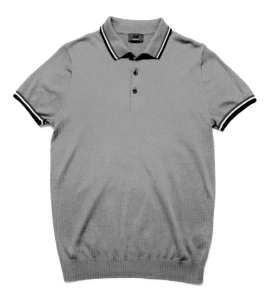

POLO SHIRT

There are a lot of new performance polos that come in moisture-wicking fabrics, but the best-looking versions are simple and pay tribute to their tennis roots. Try to find ones with the classic ribbed trim on the sleeves—it not only looks nice, it helps accentuate your arms by visually separating your shoulder and biceps.

TRY IT WITH

KHAKI WHITE TORTOISESHELL
TROUSERS TENNIS SHOES GLASSES

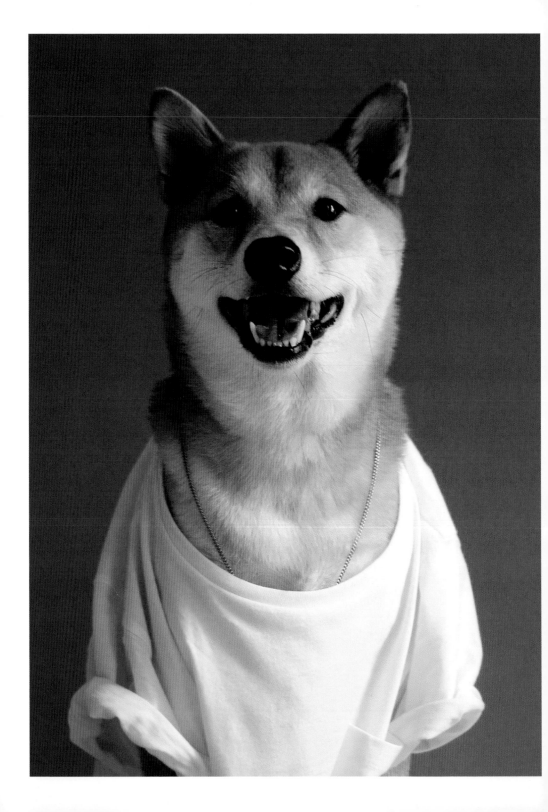

THE PERFECT T

Not to be confused with your favorite ratty Megadeth concert T, the perfect T is something much rarer—like the white dress shirt, the ideal version still eludes many. This one's really simple, guys. Invest in Ts that are 100 percent cotton and fit you like a glove (see page 142 for details). Once you nail the fit, buy at least two or three in a few colors so you're not rocking the Perfect Pit Stain. The James Dean–style crew neck is the most timeless option out there. If you have a slim or muscular frame, more extreme necklines like the V-neck or the scoop neck can look downright heroic.

TRY THESE CLASSIC STYLES

CREW NECK V-NECK SCOOP NECK

DID YOU KNOW?

The original Breton shirt featured twenty-one stripes, one for each of Napoléon's victories.

BRETON STRIPED SHIRT

The Breton striped shirt originated in the nineteenth century as part of the French naval uniform. The distinctive stripe pattern made it easy to spot sailors who had gone overboard, and the tight knit (typically made from cotton or wool) protected them from ocean wind. Its bold, time-honored style has since come to define casual cool. It's perfect on its own with jeans and sneakers, or equally dashing as a contrast piece layered under a suit. A variety of brands make their own versions, but stick with the traditional palette—white with navy or red.

TRY IT WITH

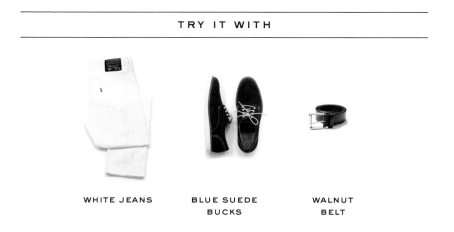

WHITE JEANS BLUE SUEDE BUCKS WALNUT BELT

THE RIGHT FIT

The cut should be slim but
roomy enough that you can
move your arms with ease.
The sleeves should be close
to but not tight around the
arms, and they should end
mid-biceps (fold the sleeves
up once or twice if they're
cut a little long). It should
be just long enough in the
body to tuck into your
pants.

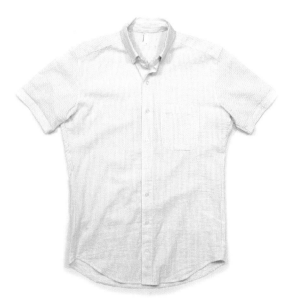

SHORT-SLEEVED BUTTON-DOWN

The short-sleeved button-down is probably one of the most misunderstood pieces in modern menswear (in large part because it is seldom worn in the correct size). But done right, it can be a stylish, comfortable way to beat the heat. It is meant to be casual, which is why the look usually falls flat when paired with a tie. Solid colors and subtle patterns like stripes are foolproof, but if you're feeling frisky, try some bolder prints like gingham or florals.

TRY IT WITH

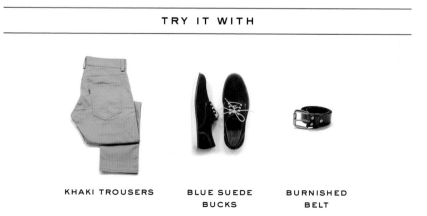

KHAKI TROUSERS BLUE SUEDE BUCKS BURNISHED BELT

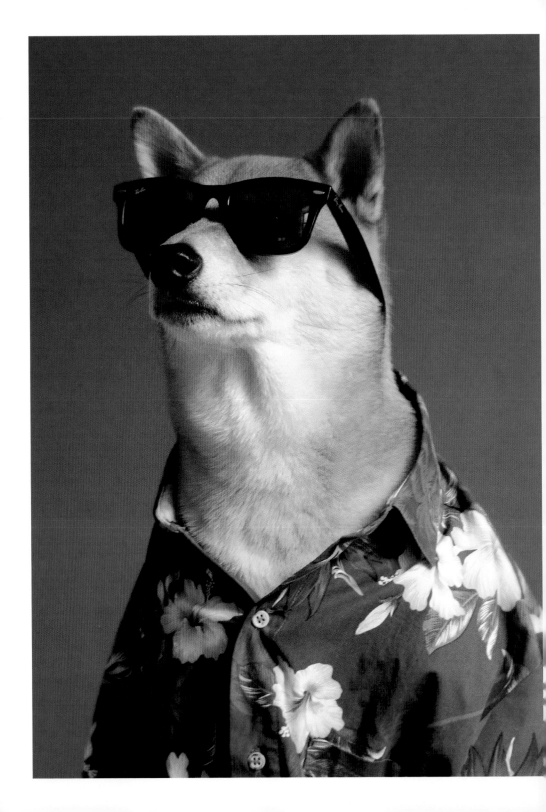

WAYFARER SUNGLASSES

Picking out a pair of sunglasses can be a harrowing experience, with lots of advice being thrown your way and far too many options to choose from. Begin by trying out a few classic shapes to see which flatters your face best and go from there. Colored frames can add visual interest and subtly tie your accessories in to your outfit, but don't go too wild—stick to shades of olive, tortoise, brown, or maroon. And unless you're a professional athlete or an X-Man, stay away from those sporty-style wraparounds.

TRY THESE OTHER CLASSIC STYLES

CLUBMASTERS AVIATORS KEYHOLE

THE MARINER

Most of us aren't spending weekends aboard a private yacht, but luckily, you don't need sailing chops to hit that perfect mark between comfortably casual and effortlessly dapper. Summer simplicity at its best, this classic look will keep you looking fresh on land or at sea.

STYLE ICONS

Paul Newman

Pablo Picasso

Jean Paul Gaultier

SEAWORTHY MUST-HAVES

1. Breton striped shirt
2. Khaki trousers
3. Colored shorts
4. Tennis shoes or boat shoes
5. Espadrilles
6. Raincoat or Windbreaker
7. Clubmaster sunglasses

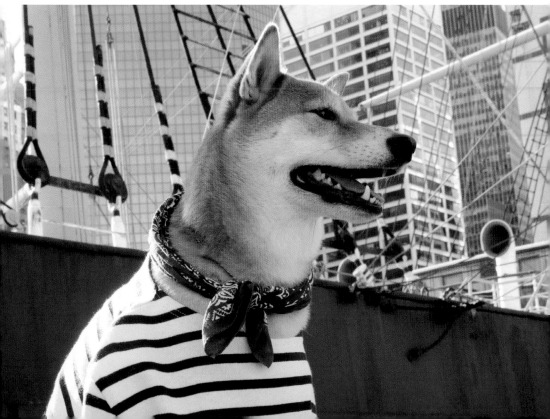

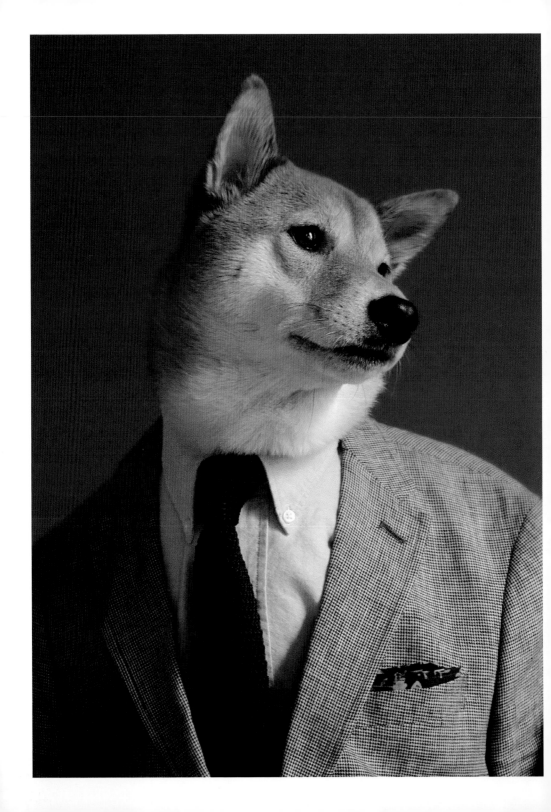

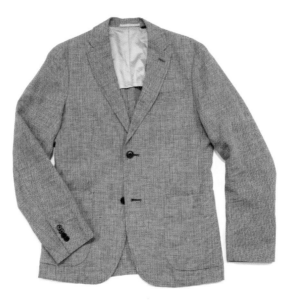

LINEN SUIT

A linen suit is the answer for cool, casual summer dressing. The fabric is breathable and virtually lint free, and the irregularities in the thread give it a casual, unique character. But be warned: after an entire day of wear, you'll be suit-deep in wrinkles, so it's better to skip this during the workweek and save it for that special outdoor event. Try pairing yours with a crisp oxford shirt for a breezy way to look put together while staying comfortable.

TRY IT WITH

OXFORD SHIRT WALNUT KNIT TIE FLORAL
 OXFORDS POCKET
 SQUARE

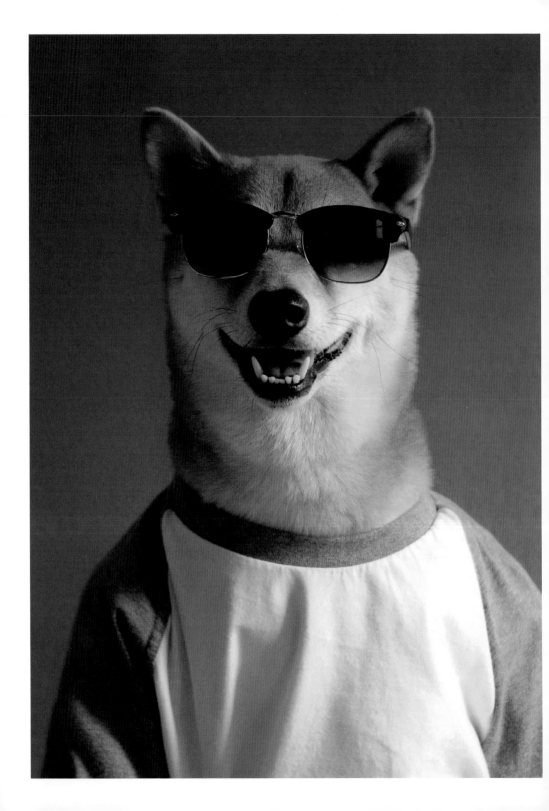

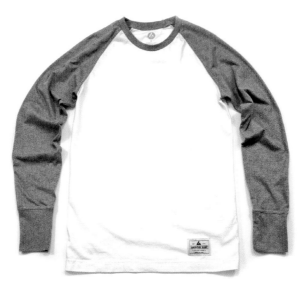

RAGLAN BASEBALL T

The raglan baseball T has contrasting-color three-quarter sleeves that create diagonal seams across the chest and narrow at the neckline. The placement of the seams helps to elongate the body as well as improve movement around the arms, and makes this style flattering and easy to wear for all shapes and sizes for casual events.

TRY IT WITH

TAPERED
JOGGERS

WHITE
TENNIS SHOES

CLUBMASTER
SUNGLASSES

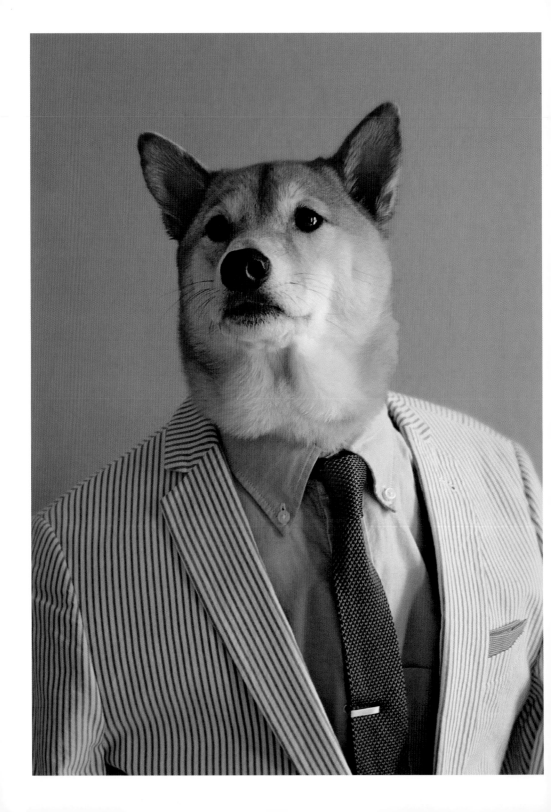

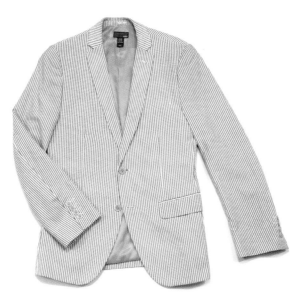

SEERSUCKER SUIT

There's nothing like a cool seersucker suit on a hot summer day. Its unique bunched-up texture means that most of the fabric is held away from the body, improving airflow and keeping the heat out. Opt for light shades like blue or gray, and finish the look with a crisp oxford shirt and a dark slim tie for an elevated summer outfit. And as if rocking this look couldn't get any easier, you can put that iron away—seersucker (like linen) actually looks more charming with a few light creases.

TRY IT WITH

OXFORD
SHIRT

BLUE SUEDE
BUCKS

KNIT TIE
& TIE BAR

STRIPED
POCKET
SQUARE

AT A SUMMER WEDDING

When summer wedding season comes around, it can be tricky to figure out what is and isn't appropriate to wear. Unless you're explicitly told that it's a casual wedding, a general rule of thumb is to opt for a suit and tie—if you end up being the dressiest guy there, just lose the tie or the jacket. But a full dark suit will most likely feel too stuffy and serious, especially if the wedding is held outdoors. Here are some more do's and don'ts to keep in mind next time you get a save-the-date:

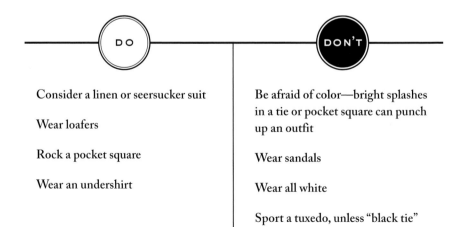

DO

Consider a linen or seersucker suit

Wear loafers

Rock a pocket square

Wear an undershirt

DON'T

Be afraid of color—bright splashes in a tie or pocket square can punch up an outfit

Wear sandals

Wear all white

Sport a tuxedo, unless "black tie" is specified on the invite

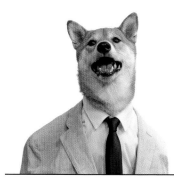

CLASSIC CONTRAST

Tan linen suit, white dress shirt,
double monk straps, black knit tie

CASUAL CHARMER

Striped linen shirt, cream suit pants,
tassel loafers, panama hat

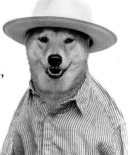

CRISP CONTENDER

White dress shirt, seersucker suit,
tassel loafers, keyhole sunglasses,
chambray pocket square

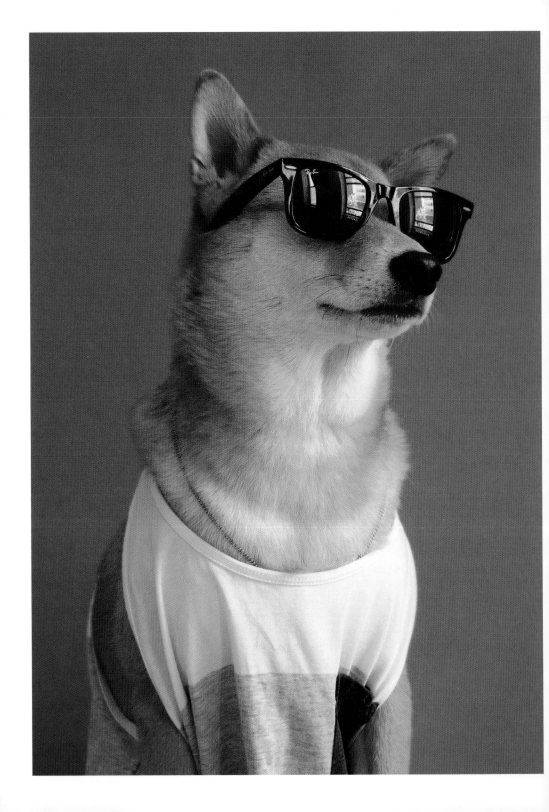

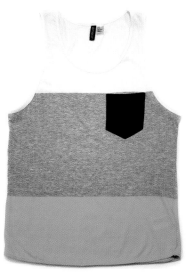

TANK TOP

The beloved tank top, in all its '80s glory, is having a revival at the moment, with a slew of designers offering throwback versions in slimmer fits, shorter crops, and a variety of shades and graphic patterns. This is purely casual fare, though, meant to be worn with jeans or shorts and only with the utmost confidence—but if you got it, flaunt it.

TRY IT WITH

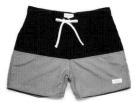

SWIM TRUNKS

SLIP-ON
ESPADRILLES

WAYFARER
SUNGLASSES

DID YOU KNOW?

Madras is mentioned several times in S. E. Hinton's 1967 classic, *The Outsiders*, to describe the fashions favored by the Socs. That's as preppy as it gets.

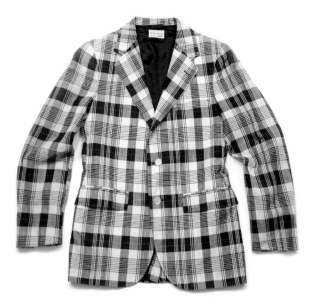

MADRAS SPORT COAT

Madras isn't a word you hear every day, but it ought to be in your fashion vocabulary. These lightweight cotton fabrics, typically with a bright plaid design, have become a standard for summer style. Madras is bold, so the trick to pulling it off is to keep everything else quiet. If a full-on madras sport coat seems a little too audacious, consider wearing other items in the pattern first to get a feel for it; shirts, pocket squares, shorts, and even shoes are great starter pieces.

TRY IT WITH

OXFORD SHIRT WHITE JEANS BURNISHED OXFORDS BURNISHED BELT

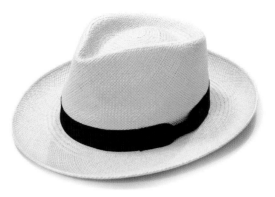

PANAMA HAT

Summer can be a confusing time for fashion; striking the right balance between comfort and style is certainly a challenge. When in doubt, throw on a Panama hat to add a touch of sophistication to an otherwise casual outfit. Form meets function here: the wide brim provides shade from the sun's rays while the lightweight straw material allows air in and out to keep your head cool.

TRY IT WITH

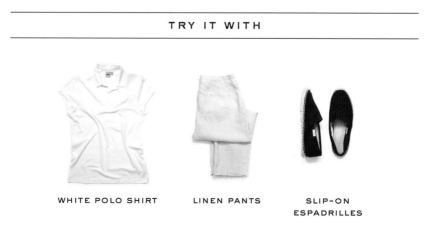

WHITE POLO SHIRT LINEN PANTS SLIP-ON ESPADRILLES

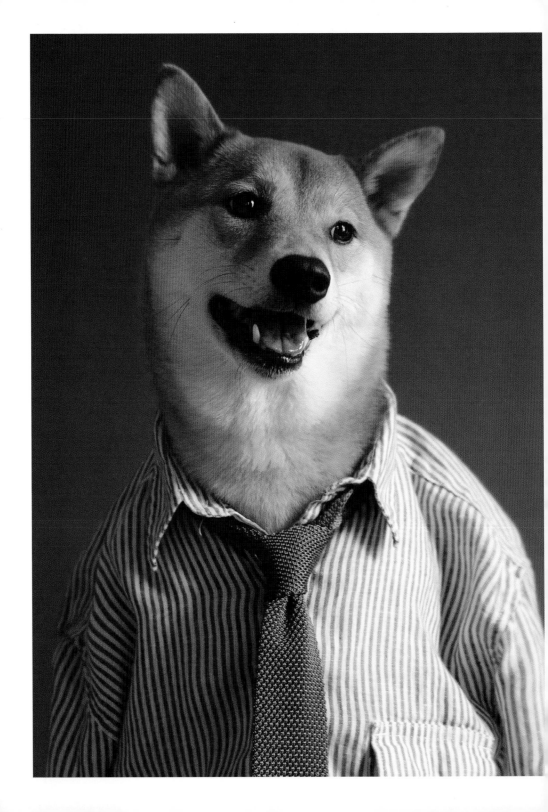

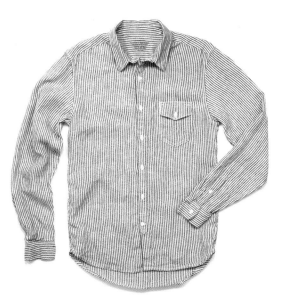

STRIPED SHIRT

A striped shirt should be a cornerstone of a modern man's wardrobe because it translates seamlessly from business to weekend casual. Here's how to make the most out of yours: avoid complementary colors and stripes that are too loud and uneasy on the eyes; stick to thin stripes, generally no wider than an inch, so you don't look like a referee; and choose vertical stripes to elongate your body. A striped shirt is one of the best items to pair with suits (with or without a coordinating tie), but it can work just as well with light jeans and sneakers.

TRY IT WITH

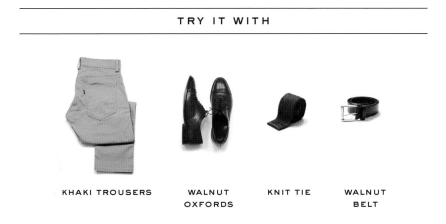

KHAKI TROUSERS WALNUT OXFORDS KNIT TIE WALNUT BELT

SUMMER ESSENTIALS

1. Perfect T
2. Polo shirt
3. Short-sleeved button-down
4. Tank top
5. Breton striped shirt
6. Raglan baseball T
7. Striped shirt
8. Linen suit
9. Seersucker suit
10. Madras sport coat
11. Light jeans
12. White jeans
13. Espadrilles
14. Tennis shoes
15. Panama hat
16. Wayfarer sunglasses

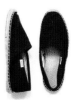

2

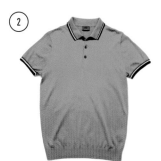

3

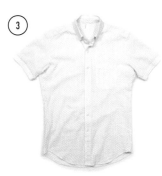

4

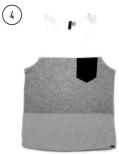

6

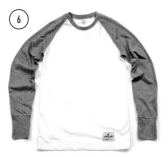

7

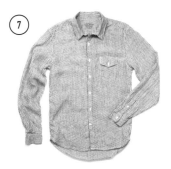

8

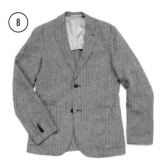

10

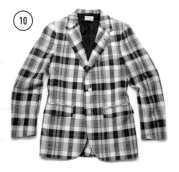

11

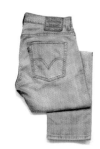

12

14

15

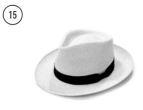

16

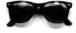

FALL

As the leaves change color and the temperature drops, it's time to start exercising your layering game. Fall brings all kinds of new textures, colors, and styles to play around with, so retire those flip-flops and pick up these must-have pieces.

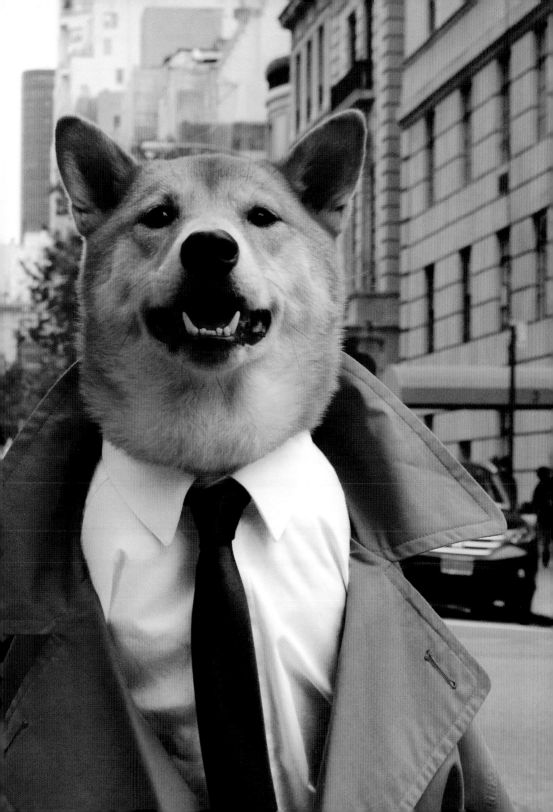

THE RIGHT FIT

The field jacket is pretty forgiving when it comes to fit, but make sure that the shoulders are just roomy enough to allow you to layer a sweater underneath the jacket and that the hem hits mid-thigh.

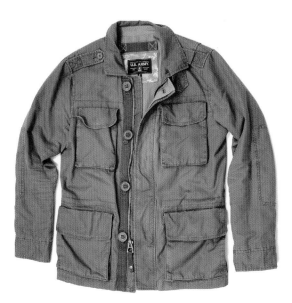

MILITARY FIELD JACKET

From De Niro in *Taxi Driver* to Stallone in *Rambo*, it doesn't get much manlier than a military field jacket. This bad boy is tough and incredibly practical, which explains why it's a fashion mainstay. The best way to get your hands on the perfect field jacket is to go vintage or surplus, but if you'd prefer to break in your own, there are plenty of new versions to choose from. Just stick to the more traditional models, with military details like shoulder epaulets, drawstring bottoms, and a four-pocket design, to ensure that your pick will never go out of style.

TRY IT WITH

| HENLEY | CHAMBRAY SHIRT | SELVEDGE DENIM JEANS | CHUNKY WORK BOOTS | KNIT BEANIE |

BEYOND BEGINNER

Gray suits in darker shades, like charcoal, are perfect for the winter months and are more adaptable than black when layering with fall colors like tan, brown, and olive. In the warmer seasons, play around with lighter shades of gray over a crisp oxford to channel your inner Don Draper.

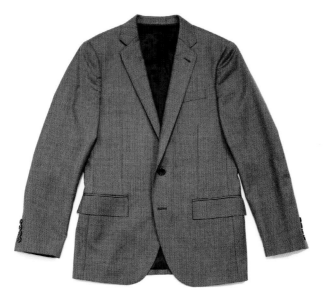

GRAY SUIT

The time-honored gray suit is a must for any man's wardrobe—it pairs well with everything. A medium gray will be your best friend all year round, carrying you from formal to casual, work to play, and day to night. Look for a single-breasted two-button suit with a notch lapel; peak lapels and double-breasted suits can look a bit too formal, and flexibility is what you're aiming for here. If you can't find the perfect fit off the rack, consider taking your suit to a tailor—you'll be wearing it so often, the investment is sure to pay off. (See page 140 for more information on how to get the right fit.)

TRY IT WITH

| CHAMBRAY SHIRT | BRETON STRIPED SWEATER | WALNUT OXFORDS | WALNUT BELT | CHAMBRAY POCKET SQUARE |

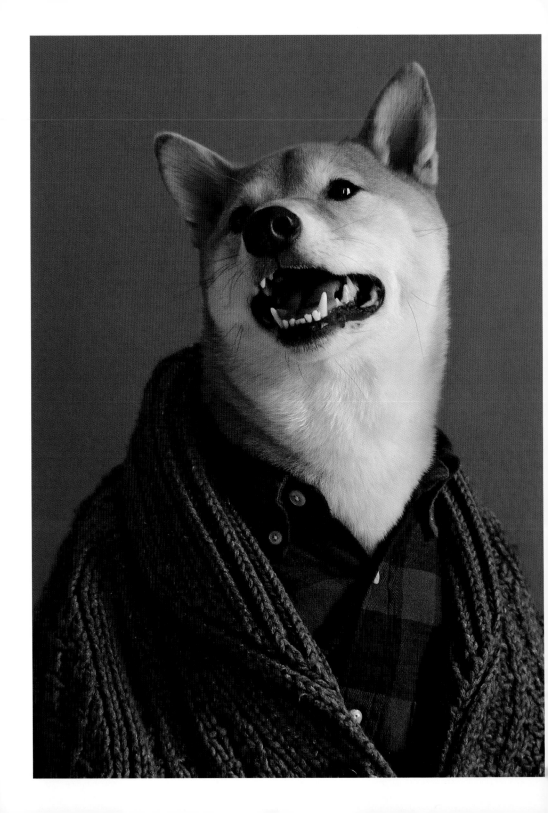

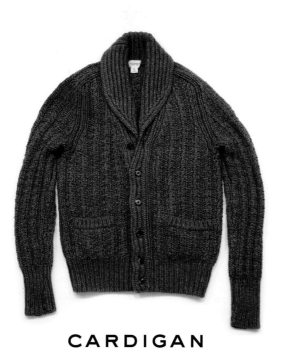

CARDIGAN

It wasn't long ago that the cardigan was considered the definition of conservative and stuffy (sorry, Mr. Rogers). But the last few years have seen the resurgence of the knit sweater—what's old is new. The cardigan is such a great piece because of its versatility; you can throw one over a shirt and tie at the office, or you can wear it with a plain T and look just as dapper.

TRY IT WITH

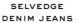

FLANNEL SHIRT **SELVEDGE DENIM JEANS** **CHUNKY WORK BOOTS**

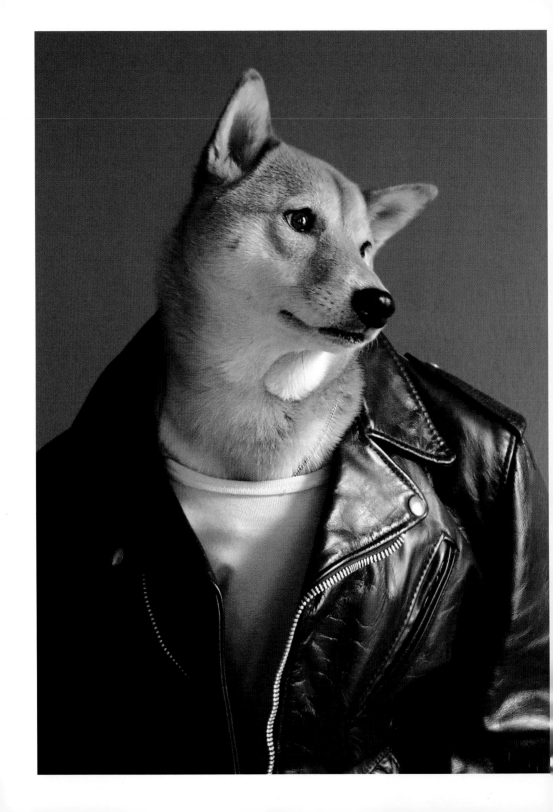

LEATHER MOTORCYCLE JACKET

Marlon Brando in *The Wild One*, Henry Winkler on *Happy Days*, and Sid Vicious of the Sex Pistols—the leather jacket has been the quintessential bad-boy standard since we can remember. First made by the Schott Bros. in 1928 for riders in search of durable and extremely stylish outerwear, the iconic look remains one of the most popular items in menswear. A true motorcycle jacket will only look better with age—every sign of wear and tear is a story to be told, so don't be too precious with it.

TRY IT WITH

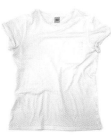

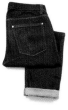

THE PERFECT T

SELVEDGE
DENIM JEANS

DOUBLE
MONK STRAPS

BEYOND BEGINNER

Once you're feeling confident with your two-button navy blazer, try experimenting with a double-breasted version—it can look downright regal. Wear it with a crisp white dress shirt sans tie for an instant style upgrade.

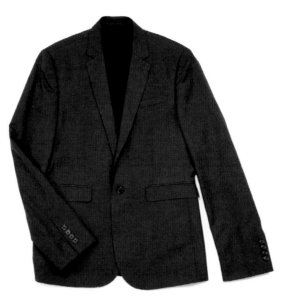

NAVY BLAZER

The navy blazer is the hardest-working item in your wardrobe, keeping you looking slick during whatever life has in store for you. First job interview? Navy blazer and knit tie. Meeting your significant other's dad? Navy blazer and polo shirt. Wednesday at the office? Navy blazer and crisp white T. You won't regret spending a little extra to get this one right. Start with a cotton or wool two-button version with a slim lapel, and make sure it's well-tailored so you don't look like you're wearing your dad's suit. (See page 140 for more information on getting the right fit.)

TRY IT WITH

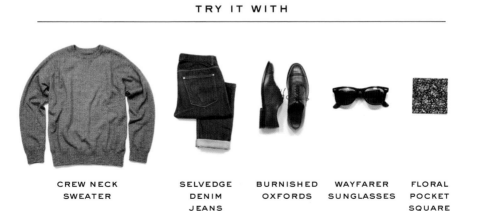

CREW NECK
SWEATER

SELVEDGE
DENIM
JEANS

BURNISHED
OXFORDS

WAYFARER
SUNGLASSES

FLORAL
POCKET
SQUARE

THE IVY LEAGUER

The Ivy Leaguer is smart and sophisticated but never stuffy. He looks crisp but manages to remain comfortable. When done right, a preppy wardrobe translates seamlessly from campus to corporate, and helps you stand out thanks to well-chosen pops of color.

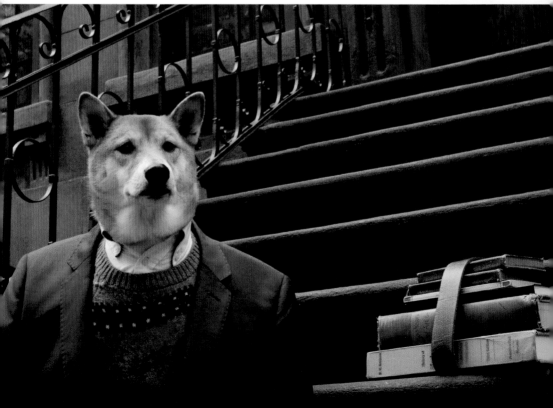

13
PREPPY
MUST-HAVES

1. Navy blazer
2. Tweed blazer
3. Oxford shirt
4. Cardigan
5. Fair Isle sweater
6. Khaki trousers
7. White jeans
8. Loafers
9. Varsity jacket
10. Clubmaster sunglasses
11. Striped tie
12. Knit tie
13. Suspenders

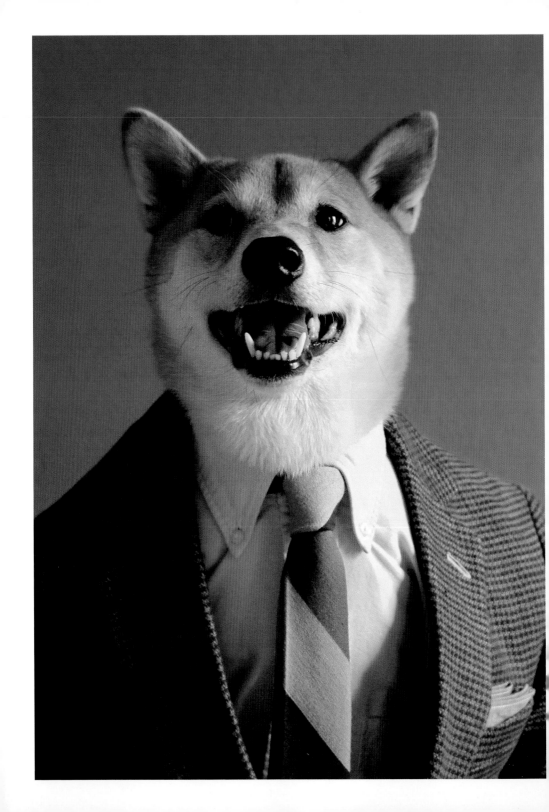

OXFORD BUTTON-DOWN

The perfect weapon in your casual-to-formal arsenal—the heavier-weight fabric and collar button detail of the oxford give it more visual interest than your typical crisp cotton shirt. Consider this the glue that keeps an outfit together, providing an excellent base to pair with any number of jackets, sweaters, ties, or trousers. Once you find one with the right fit (see page 138), pick it up in a variety of colors and start experimenting.

TRY IT WITH

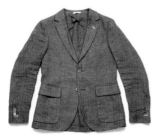

| TEXTURED BLAZER | NAVY TROUSERS | BURNISHED OXFORDS | BOLD TIE | CHAMBRAY POCKET SQUARE |

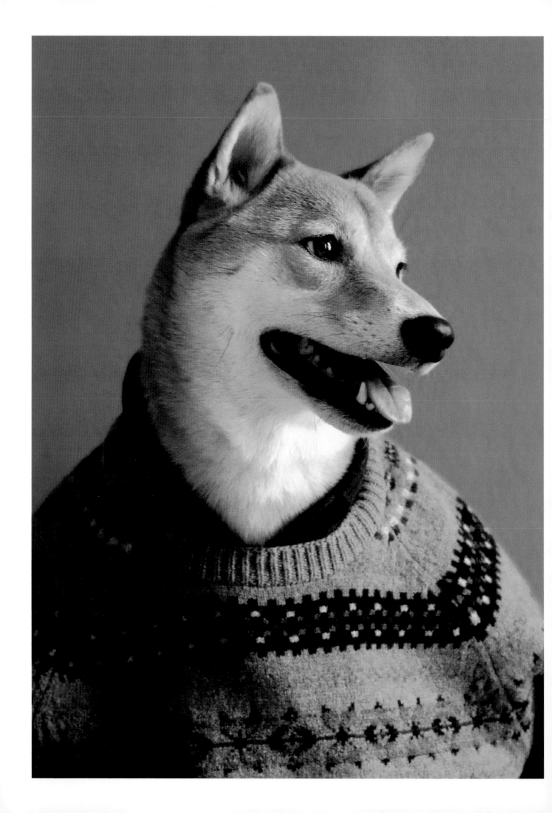

FAIR ISLE SWEATER

The Fair Isle sweater employs a traditional Scottish knitting technique to create beautiful patterns, often with multiple colors. The style and colors can vary greatly, but stick with muted shades with touches of bright accents. It looks great over an oxford shirt and under any suit in a complementary shade. Try one under a leather motorcycle jacket for a fun, unexpected contrast.

TRY IT WITH

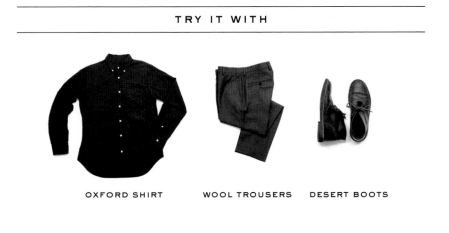

OXFORD SHIRT WOOL TROUSERS DESERT BOOTS

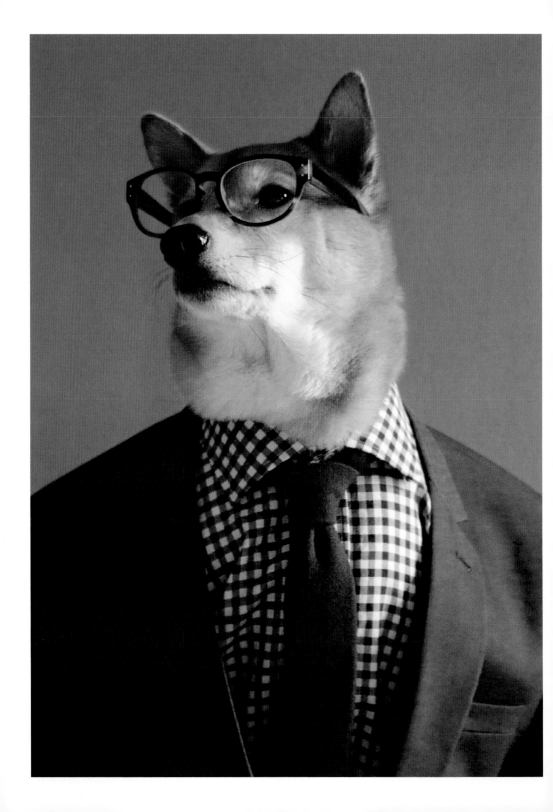

GINGHAM SHIRT

Gingham should become your go-to checked pattern. Unlike the bolder alternatives, it adds interest to an outfit without overwhelming it, allowing you to rock a pattern plus a bright tie. You can find gingham shirts in almost any color, but you should also try the pattern in items like ties, bow ties, or pocket squares. Just don't wear more than one gingham item per outfit, or you might end up looking like a picnic table.

TRY IT WITH

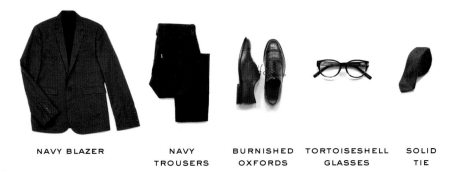

| NAVY BLAZER | NAVY TROUSERS | BURNISHED OXFORDS | TORTOISESHELL GLASSES | SOLID TIE |

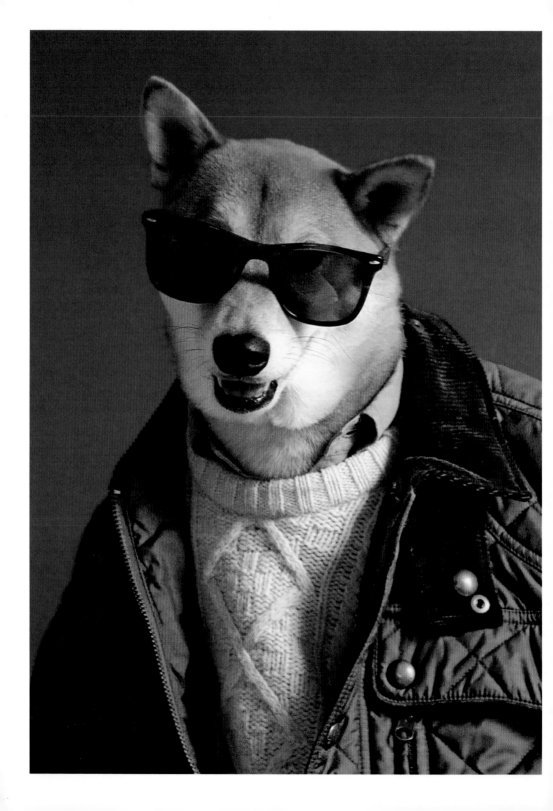

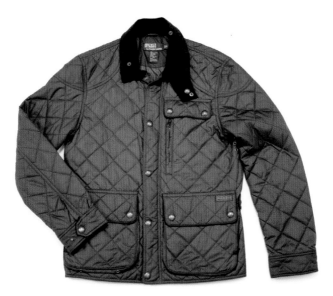

QUILTED JACKET

You can't help but conjure images of foxhunting on a sprawling English estate when wearing one of these jackets, originally popularized by the British royal family. The quilting creates air pockets that trap in heat, and it's thin enough to layer under a textured blazer or coat yet substantial enough to wear as outerwear. Give a nod to its aristocratic roots by pairing it with preppy staples like rep ties and oxford shirts.

TRY IT WITH

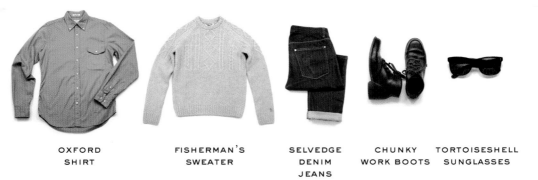

| OXFORD SHIRT | FISHERMAN'S SWEATER | SELVEDGE DENIM JEANS | CHUNKY WORK BOOTS | TORTOISESHELL SUNGLASSES |

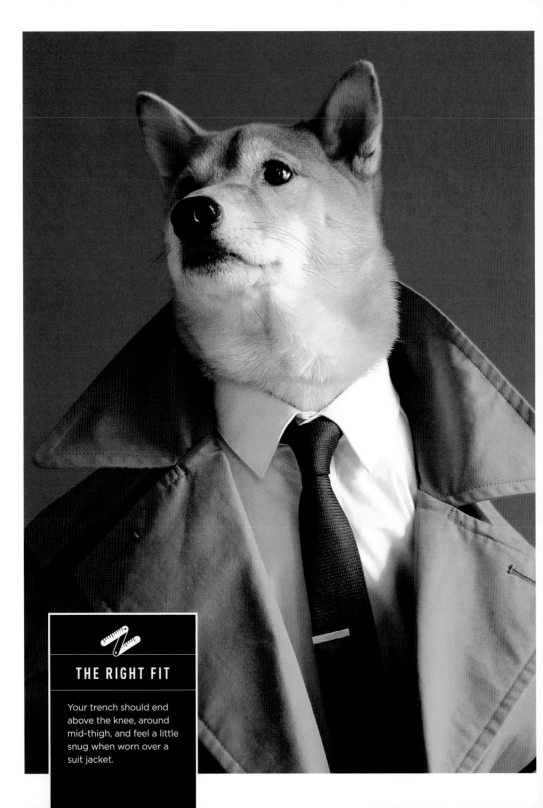

THE RIGHT FIT

Your trench should end above the knee, around mid-thigh, and feel a little snug when worn over a suit jacket.

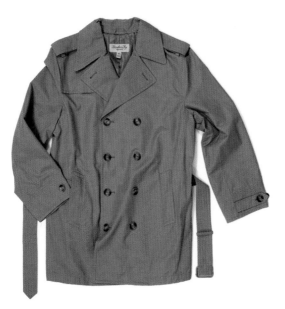

TRENCH COAT

There's something undeniably powerful about a man in a trench coat—think Humphrey Bogart in *Casablanca*, Michael Caine in *Get Carter*, and Harrison Ford in *Blade Runner*. There are many versions of the trench out there, but the core features (cream or tan with epaulets and a removable belt) have remained consistent for over a century—a testament to its functionality and timeless aesthetic. Top it off with a fedora or a trilby and loosely tie the belt (rather than buckle it) for a less stuffy look.

TRY IT WITH

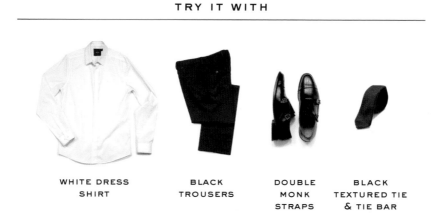

WHITE DRESS
SHIRT

BLACK
TROUSERS

DOUBLE
MONK
STRAPS

BLACK
TEXTURED TIE
& TIE BAR

AT THE OFFICE

Many offices are getting more relaxed with their dress code, leaving a lot of guys confused about what to wear to work in the morning. When it comes to appropriate work attire, it's better to be a little overdressed than underdressed. Here are the do's and don'ts to keep you looking stylish while you work your way to the top.

DO

Break up a suit—wear the jacket with jeans or dress pants and a casual shirt

Punch up your white shirt plus dark suit combo with a colorful patterned pocket square

Play around with gingham and stripes

Invest in a pair of black oxford shoes—they will go with any suit

DON'T

Let your tie hang below your belt

Wear a T-shirt every day

Wear white socks with your dark dress shoes—you're not Michael Jackson

Wear sandals or flip-flops, even if it's Casual Friday

Wear a linen suit, since it wrinkles easily

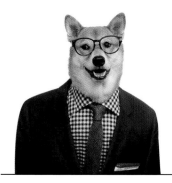

CORPORATE

Gingham shirt, navy suit, double monk straps, tortoiseshell glasses, textured tie, solid pocket square

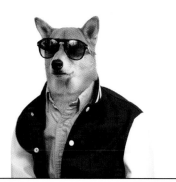

CREATIVE

Oxford shirt, dark jeans, walnut oxfords, varsity jacket, keyhole sunglasses

INTERVIEW

White dress shirt, dark two-piece suit (with two-button jacket), walnut oxfords, knit tie, gingham pocket square, walnut belt

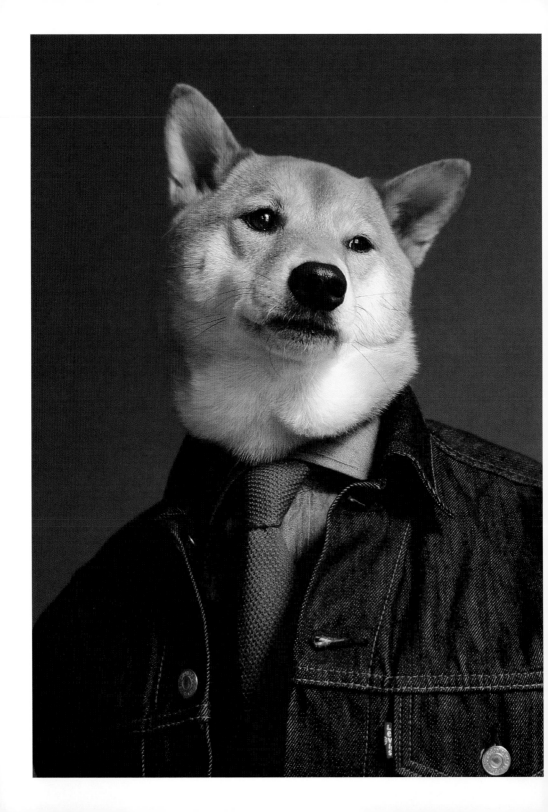

KNIT TIE

It's time to say good-bye to wide, super-shiny ties and hello to the world of slim knit ties. Unlike the classic power tie, a knit tie can be paired with any variety of shirt and suit, and it can easily go from sophisticated to casual without missing a beat. Silk knit ties are great year-round, lending texture and sheen to an otherwise bland outfit. Wool versions are best reserved for fall or winter and can add some tooth to a navy or gray suit. Consider coordinating the tie with a pocket square for an elevated combo.

TRY IT WITH

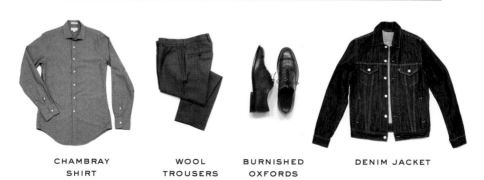

CHAMBRAY
SHIRT

WOOL
TROUSERS

BURNISHED
OXFORDS

DENIM JACKET

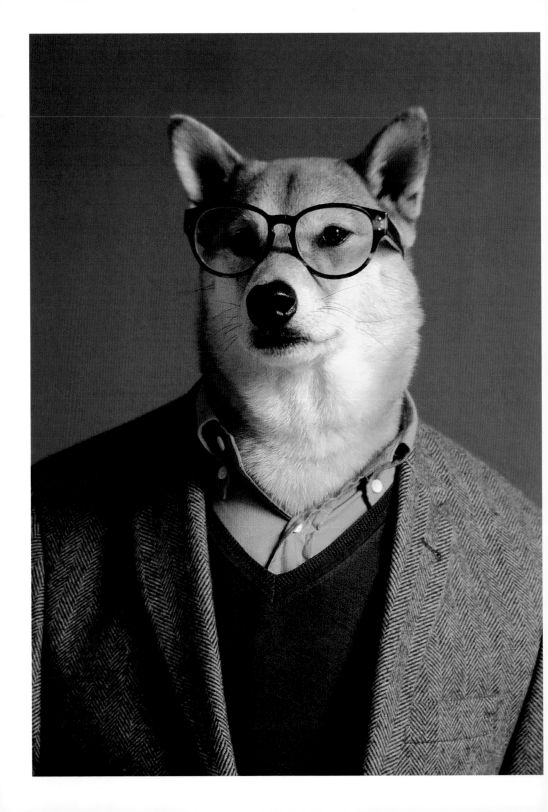

CASHMERE SWEATER

Characterized by its fine texture, cashmere is a downy wool made from the undercoat of goats and is known to be incredibly soft, strong, and light. It provides great insulation without causing overheating, making a cashmere sweater one of the most comfortable pieces of cold-weather clothing you can buy. The price difference between cashmere and a less expensive material like merino wool is significant, but cashmere fits better, feels softer, and will ultimately last longer, so it's well worth the investment.

TRY IT WITH

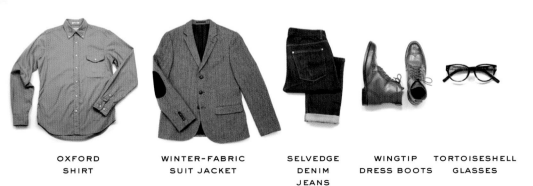

OXFORD
SHIRT

WINTER-FABRIC
SUIT JACKET

SELVEDGE
DENIM
JEANS

WINGTIP
DRESS BOOTS

TORTOISESHELL
GLASSES

FALL ESSENTIALS

1. Gingham shirt
2. Oxford button-down
3. Cashmere sweater
4. Fair Isle sweater
5. Cardigan
6. Gray suit
7. Navy blazer
8. Trench coat
9. Quilted jacket
10. Leather motorcycle jacket
11. Military field jacket
12. Selvedge denim jeans
13. Navy trousers
14. Double monk straps
15. Walnut oxfords
16. Knit tie

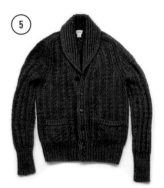

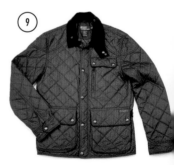

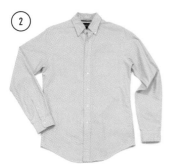

2

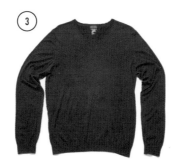

3

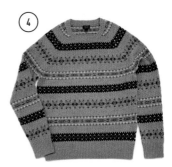

4

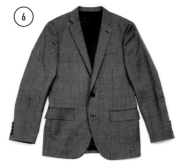

6

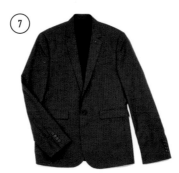

7

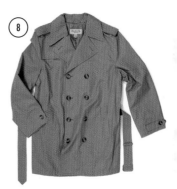

8

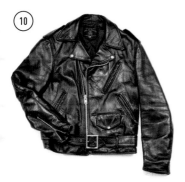

10

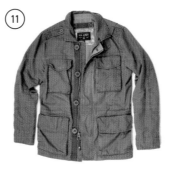

11

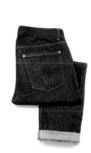

12

14

15

16

WINTER

Don't hide under a dark coat all season long. Winter is the perfect time to stand out from a sea of black and gray suits with pops of color and toothy textures. (And you can transition much of your fall wardrobe with the addition of hard-playing outerwear pieces.) Here are our suggestions to keep you looking suave and staying snug.

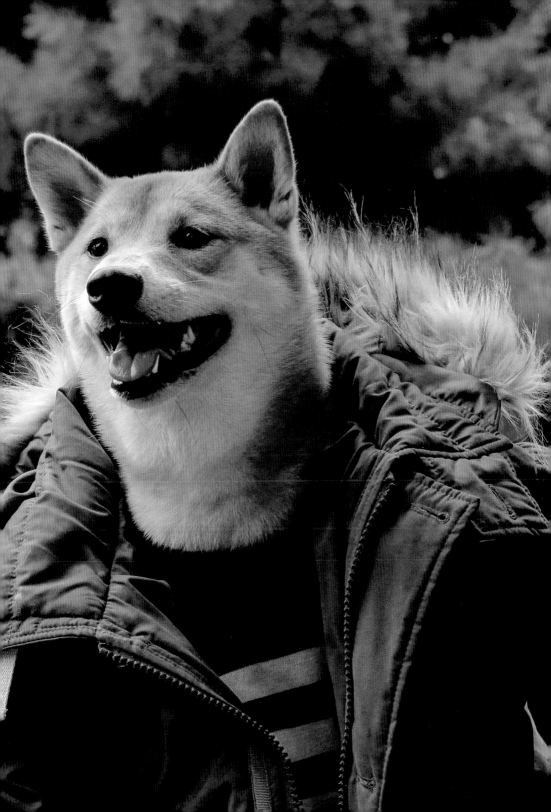

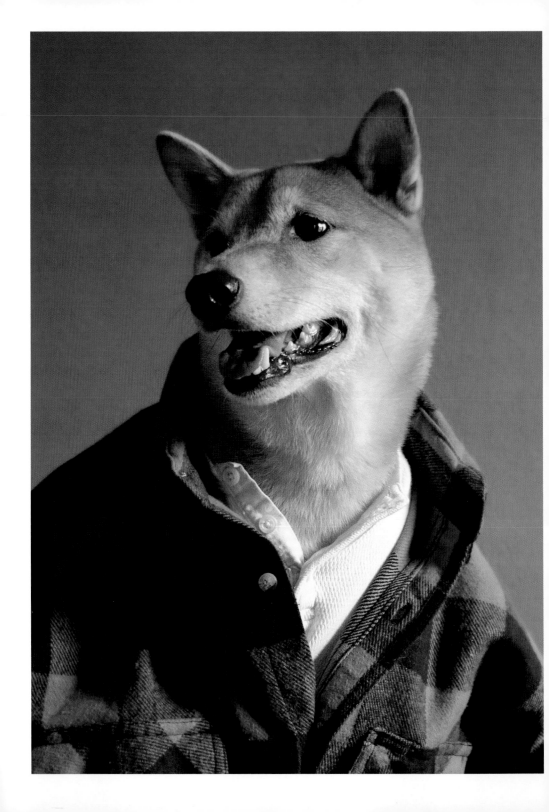

FLANNEL SHIRT

The term *flannel* is often misapplied to any shirt that has a plaid or tartan pattern, but a true flannel is made of loosely spun yarn, the fabric often finished with a fine metal brush to create extra softness and comfort. Its rugged everyman vibe has always been part of its appeal, and when '90s grunge rockers started to adopt the style, it was cemented in music and fashion history. As Kurt Cobain would tell you, when it comes to flannel, the more worn in the better.

TRY IT WITH

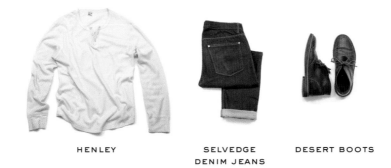

HENLEY SELVEDGE DESERT BOOTS
 DENIM JEANS

(i)

DID YOU KNOW?

Deep-sea explorer Jacques Cousteau was famous for his signature red knit beanie (Bill Murray pays tribute to this look in *The Life Aquatic with Steve Zissou*). Ever wonder why? The temperature at the bottom of the ocean hovers around 30 degrees Fahrenheit.

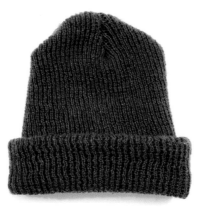

KNIT BEANIE

If you're looking for functional headgear to keep you warm in the winter, the knit beanie is all you really need. It's simple and timeless, and it keeps your head cozy and your mom happy. The more functional they are, the better they look, so don't get too fancy with this one.

TRY IT WITH

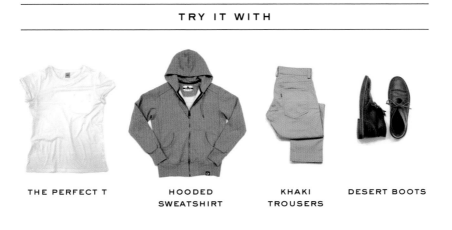

THE PERFECT T HOODED KHAKI DESERT BOOTS
SWEATSHIRT TROUSERS

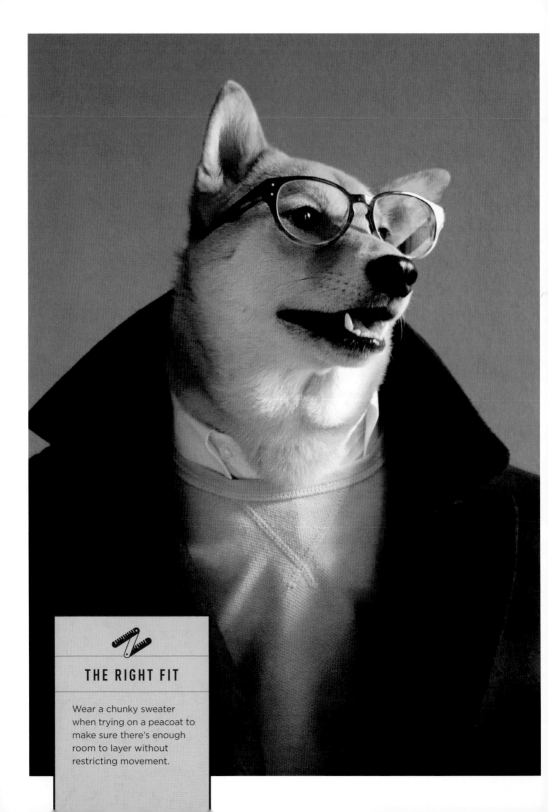

THE RIGHT FIT

Wear a chunky sweater when trying on a peacoat to make sure there's enough room to layer without restricting movement.

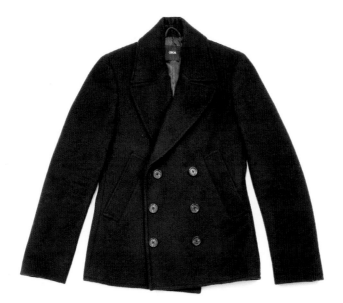

PEACOAT

Originally worn by sailors, the peacoat (also known as a pilot jacket) can't be beat in terms of functionality and durability. Peacoats are most often seen in navy blue or gray, are typically made of heavy wool, and are characterized by their double-breasted fronts and broad lapels. This is a piece that you really can't mess up— as long as it's a good fit. When you button it up, it should feel snug but not stifling.

TRY IT WITH

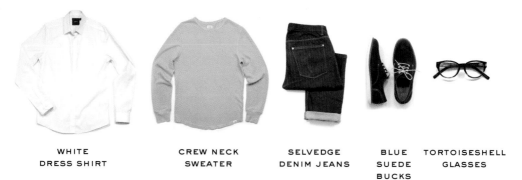

| WHITE DRESS SHIRT | CREW NECK SWEATER | SELVEDGE DENIM JEANS | BLUE SUEDE BUCKS | TORTOISESHELL GLASSES |

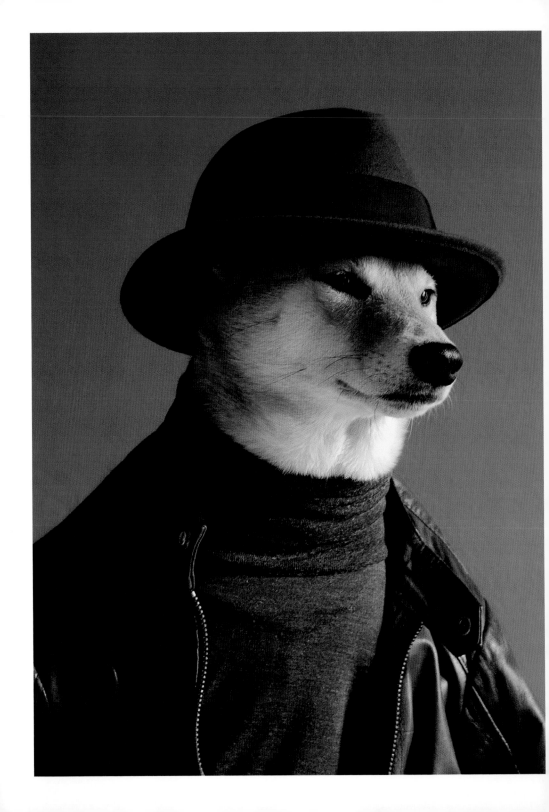

TURTLENECK

The turtleneck was once considered a bold fashion statement in menswear, a revolt against the status quo of typical office attire. Though not quite rebellious anymore, it remains a sleek substitute for the traditional shirt-and-tie look. It's surprisingly comfortable, figure flattering, and the classiest way to dress down a suit while still looking incredibly put together. Check out Steve McQueen in *Bullitt* for a master class in how to wear a turtleneck like a boss.

TRY IT WITH

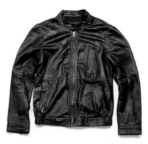

| BLACK TROUSERS | DOUBLE MONK STRAPS | BROWN LEATHER JACKET | GRAY FEDORA |

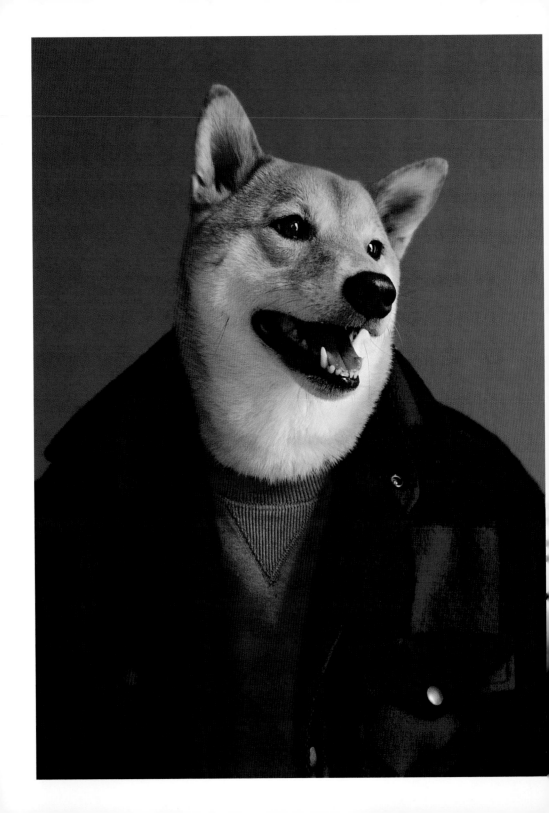

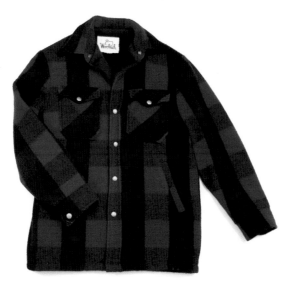

BUFFALO PLAID WOOL JACKET

Though it conjures up vivid images of the Wild West and the Marlboro Man, buffalo plaid is actually among the oldest Scottish tartans (see page 17), and first became fashionable in America in the early twentieth century, when the fictional lumberjack Paul Bunyan was depicted wearing buffalo plaid while performing his superhuman labors. Pair one of these jackets with a Henley and the dirtiest pair of boots you own and you'll be ready to chop down trees for a living—or at least look like you could.

TRY IT WITH

CREW NECK
SWEATER

SELVEDGE
DENIM JEANS

CHUNKY WORK
BOOTS

THE OUTDOORSMAN

The epitome of all-American manliness, the outdoorsman is one with Nature and knows how to dress for whatever she's got in store. He opts for well-made heritage pieces that are durable enough for hard labor and keep him comfortable in the elements.

STYLE ICONS

Ernest Hemingway

Hugh Jackman in *The Wolverine*

Heath Ledger in *Brokeback Mountain*

Nick Offerman in *Parks and Recreation*

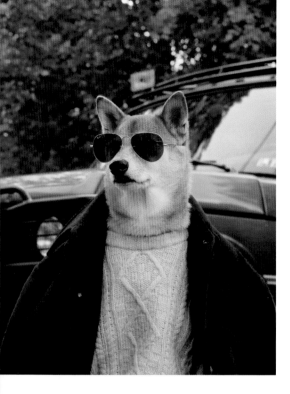

9

RUGGED
MUST-HAVES

1. Henley
2. Flannel shirt
3. Chambray shirt
4. Crew neck sweater
5. Fisherman's sweater
6. Khaki trousers
7. Dark denim jeans
8. Chunky work boots
9. Buffalo plaid jacket

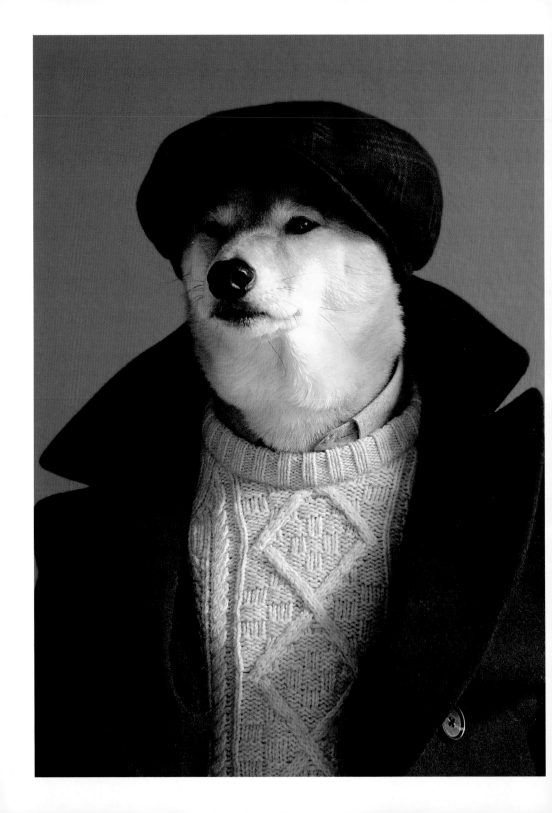

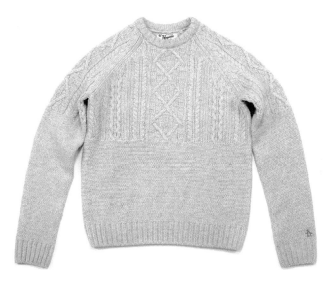

FISHERMAN'S SWEATER

The fisherman's sweater (also known as the cable-knit sweater or Aran jumper) is distinguished by its complex stitching, often in cable patterns across the chest. Like the Irish fishermen who originally wore this garment, you'll appreciate its bulk (and water-resistant wool) when the weather gets particularly brutal. Unless you buy a top-of-the-line version, this sweater is going to be itchy, so we'd recommend wearing a long-sleeved T-shirt or oxford underneath. Its wonderful texture pairs especially well with something completely different in feel, like a leather jacket. And don't worry about handling it with care; this sweater is practically bulletproof.

TRY IT WITH

OXFORD SHIRT　　　**KHAKI TROUSERS**　　　**CHUNKY WORK BOOTS**　　　**NAVY PEACOAT**　　　**NEWSBOY CAP**

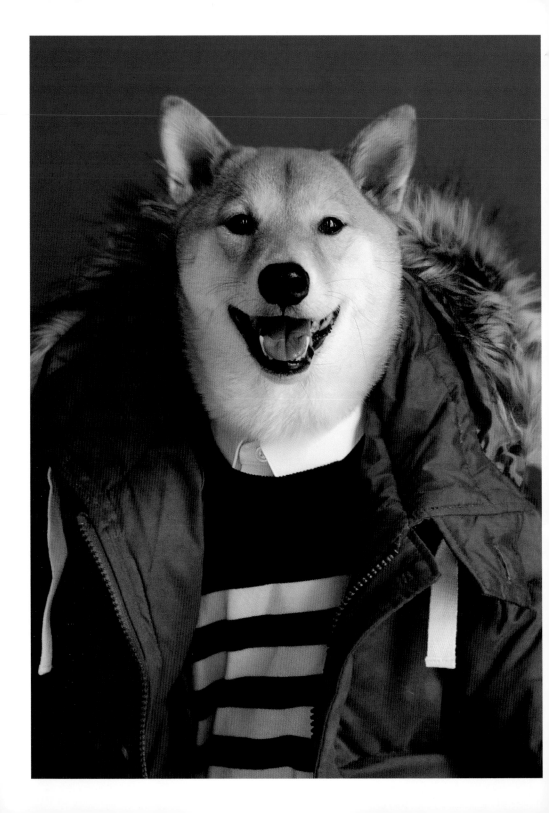

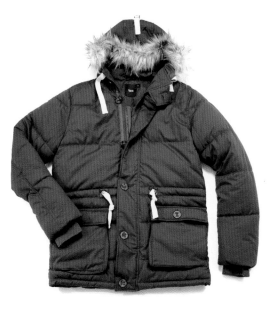

GOOSE-DOWN PARKA

Historically, parkas have been big bulky messes that were a necessary evil to keep us safe from the elements. Today's versions bridge the gap between function and fashion; they are still built to take a beating, but they're available in much slimmer cuts. Opt for one with a hood (ideally, a removable one in case it gets too cumbersome), and in a color that isn't too loud. Functional and versatile, it will look just as great over a suit and tie as it does with a sweater and beanie.

TRY IT WITH

WHITE
DRESS SHIRT

BRETON STRIPED
SWEATER

KHAKI
TROUSERS

CHUNKY
WORK BOOTS

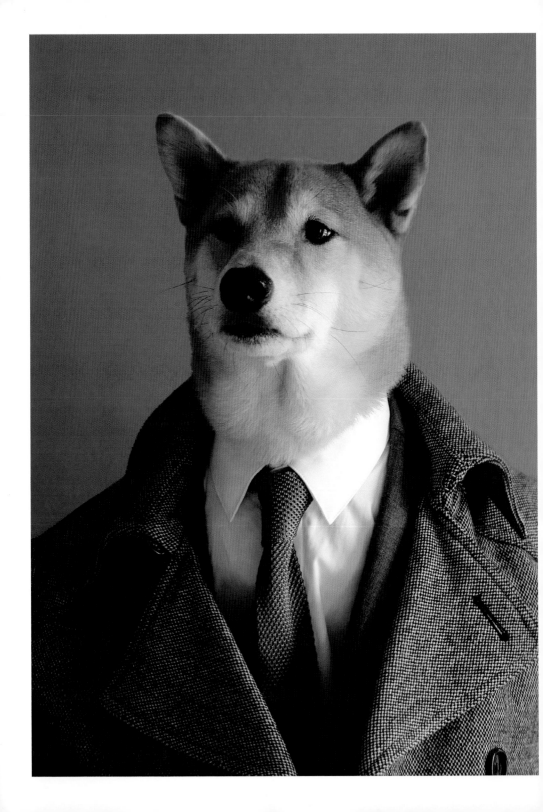

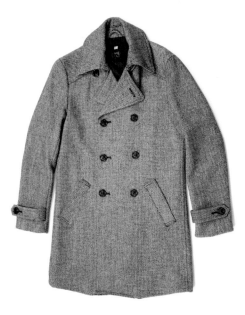

OVERCOAT

If you wear suits regularly and live in an area that gets snow, an overcoat is key to staying warm and well dressed all winter long. Overcoats are meant to be a little roomier in the body as they're typically worn over a suit jacket, so make sure there's some give (or, better yet, wear a jacket while picking yours out). Top it off with a scarf and fedora for that throwback Clark Kent look.

TRY IT WITH

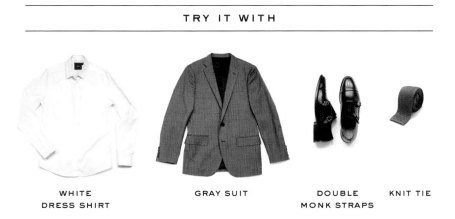

WHITE
DRESS SHIRT

GRAY SUIT

DOUBLE
MONK STRAPS

KNIT TIE

AT A BLACK-TIE EVENT

Before you head out to rent a tuxedo for your next black-tie event, consider this: you'll never get a perfect fit off the rack, and there's a good chance that you're going to need a black dinner jacket again. Invest in a formal look once, and you'll be ready whenever opportunity knocks.

DO	DON'T
Take your suit to a tailor	Rent your suit
Wear black or midnight blue	Try to dress down your tuxedo
Experiment with satin or grosgrain lapels	Wear any color shirt but white
Wear a turndown-collar white shirt	Turn up the hem of your dress pants
Try a three-piece suit	Wear sneakers or any non-dressy shoes
Wear a bow tie	

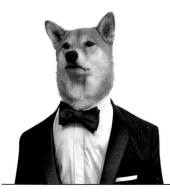

CONSERVATIVE

White dress shirt, black tuxedo with satin lapels, black oxfords, black bow tie, white pocket square, cuff links

CREATIVE

White dress shirt, maroon velvet tuxedo jacket, black tuxedo pants, tassel loafers, tortoiseshell glasses, black bow tie, cuff links

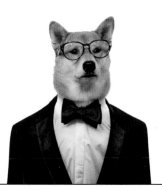

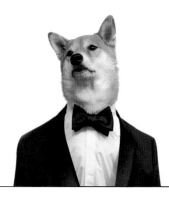

COUTURE

White dress shirt, midnight-blue tuxedo with black satin lapels, black velvet slippers, black bow tie, cuff links

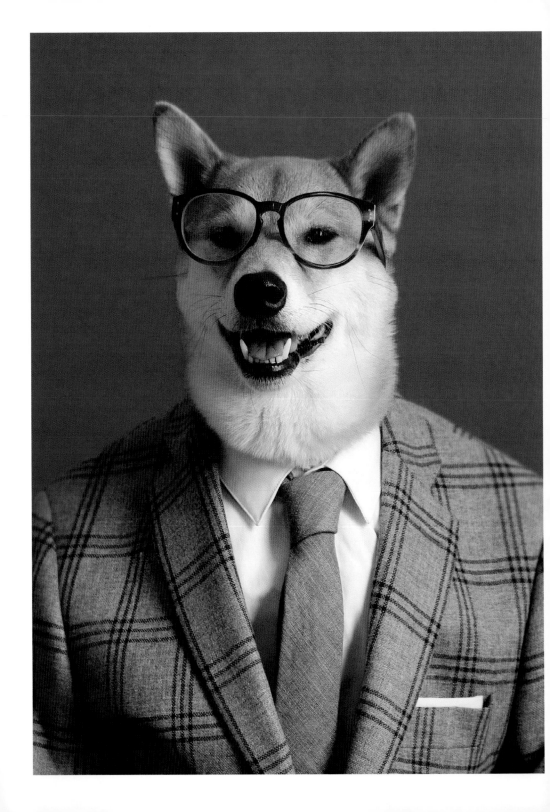

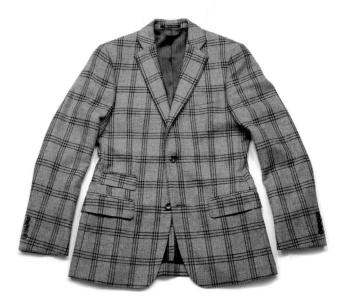

PLAID SUIT

A plaid suit will help you stand out from the crowd when things get dreary. To avoid looking overly loud, keep your shirt and tie solid and in shades that complement the suit. Pro Tip: Get the full suit, but wear the pieces as separates. A full plaid suit can be visually jarring, and breaking up the pieces gives you more options.

TRY IT WITH

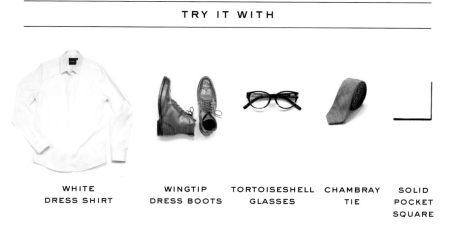

| WHITE DRESS SHIRT | WINGTIP DRESS BOOTS | TORTOISESHELL GLASSES | CHAMBRAY TIE | SOLID POCKET SQUARE |

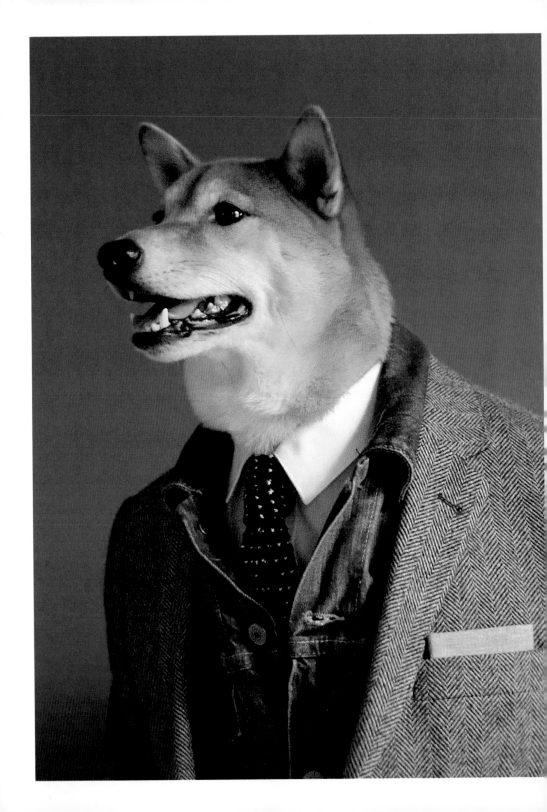

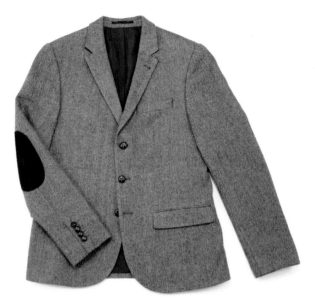

WINTER-FABRIC SUIT

"Winter-fabric suit" is really just our catchall phrase for any suit with a bit more weight and tooth to the fabric. Think wool, tweed, and weaves like houndstooth and herringbone. The extra heft of these fabrics will keep you warm, and their earthy texture will give your suit more character. Rock the full suit with a chambray shirt and a dark knit tie for a dashing statement, or wear the jacket and pants as separates; you'll look smart either way.

TRY IT WITH

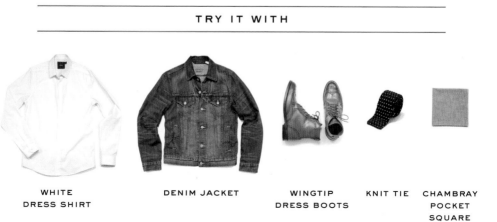

WHITE
DRESS SHIRT

DENIM JACKET

WINGTIP
DRESS BOOTS

KNIT TIE

CHAMBRAY
POCKET
SQUARE

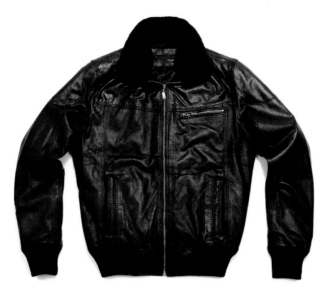

BOMBER JACKET

Designed to keep pilots warm while in flight, the bomber is characterized by its wool or shearling lining and collar. Today there are plenty of brands doing their own take on the bomber: look for modern, slimmed-down versions in materials like wool or leather. For an unexpected tough-guy vibe, try treating the bomber just like you would your blazer, tie and all.

TRY IT WITH

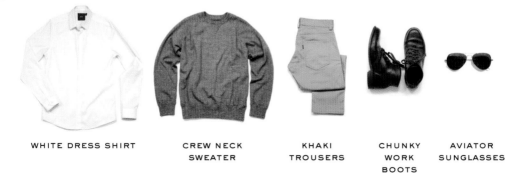

| WHITE DRESS SHIRT | CREW NECK SWEATER | KHAKI TROUSERS | CHUNKY WORK BOOTS | AVIATOR SUNGLASSES |

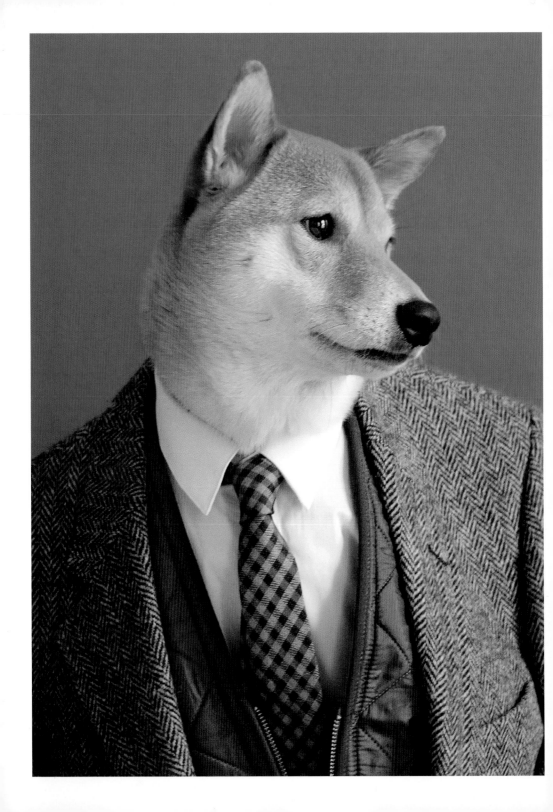

QUILTED VEST

The quilted vest doesn't get the credit it deserves. It's one of the most practical pieces in this book and looks great with just about anything you own. The quilting will keep you warm, but the material is thin enough that it won't weigh you down. Try it under a suit jacket for a modern take on the three-piece suit—without all the stuffiness.

TRY IT WITH

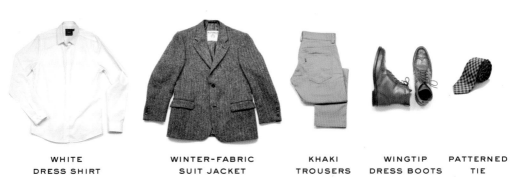

| WHITE DRESS SHIRT | WINTER-FABRIC SUIT JACKET | KHAKI TROUSERS | WINGTIP DRESS BOOTS | PATTERNED TIE |

WINTER ESSENTIALS

1. Flannel shirt
2. Turtleneck
3. Fisherman's sweater
4. Quilted vest
5. Plaid suit
6. Winter fabric suit
7. Overcoat
8. Peacoat
9. Goose-down parka
10. Buffalo plaid wool jacket
11. Bomber jacket
12. Black trousers
13. Chunky work boots
14. Walnut cap toe boots
15. Newsboy cap
16. Knit beanie

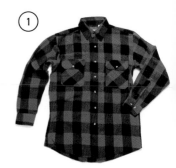

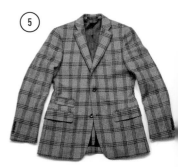

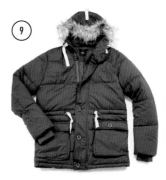

(2)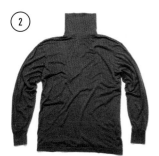

(3)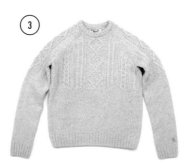

(4)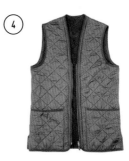

(6)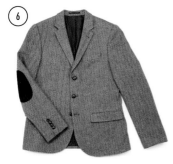

(7)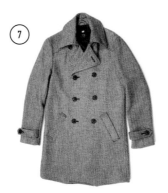

(8)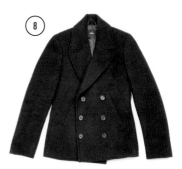

(10)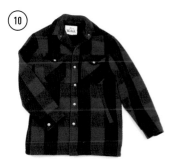

(11)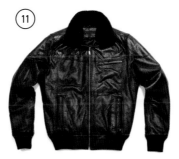

(12)

(14)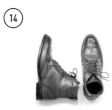

(15)

(16)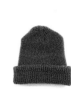

FIT

If clothes make the man, fit makes the man look good. No matter how stylish your duds are—whether you're wearing jeans and a T-shirt or a perfectly pressed suit—if they don't fit, you're going to look sloppy.

DRESS SHIRT

1. Collar: When your collar is buttoned, you should be able to fit just one or two fingers between the fabric and your neck.

2. Shoulders: The shoulder seams should hit the edge of your shoulder bone. If the seam extends to the side of your arm, the shirt is too big.

3. Armhole: The armhole should be close to your armpit, but low enough that it doesn't constrict movement. The smaller the armhole, the slimmer the sleeves, giving your shirts a more tailored feel.

4. Sleeves: When buttoned, the sleeve should hit where your hand meets your wrist.

5. Body: Shirts with back darts help taper the waist for a better fit. A good tailor can add darts to existing shirts so they have a slimmer cut.

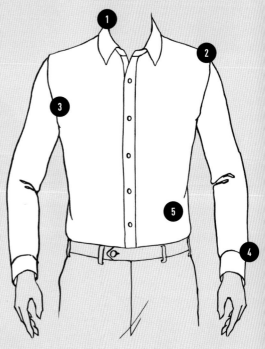

FOUR-IN-HAND:
THE ONLY KNOT YOU'LL NEED

Modern collars and lapels are getting smaller and slimmer, and they call for a knot that doesn't overpower. The four-in-hand is the perfect fit: its slender profile, slight asymmetry, and no-nonsense appeal keep you looking elegant without seeming like you're trying too hard.

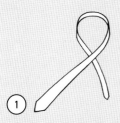

1 Begin with the wide end of the tie hanging approximately 1 foot lower than the narrow end. Cross the wide end over the narrow end.

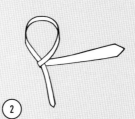

2 Bring the wide end underneath the narrow end.

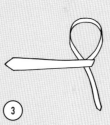

3 Double back over the narrow end.

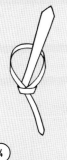

4 Pull the wide end up and through the loop around your neck.

5 Lightly hold the front knot with your finger while pulling the wide end through the loop.

6 Remove your finger and tighten the knot by sliding it upward.

7 Make sure your tie looks well-balanced and the narrow end is hidden. It should not extend past the waist of your pants.

SUIT JACKET

1. Buttons: One- or two-button suits are the most timeless.

2. Lapel: Choose whether or not you want your lapel to be peak or notch (notch is typically less formal), and keep it between 2½ and 3 inches at its widest point.

3. Shoulders: Make sure it's a soft shoulder (one without extra padding) and that the seam hits about an inch out from your shoulder bone. If the shoulder bunches when you stand with your side against a wall, the jacket is too large.

4. Sleeves: The sleeve should hit right around your wrist bone—you want to be able to show a bit of your shirt's cuff.

5. Body: Your jacket should taper in the midsection, allowing you to button it up snugly without causing puckering. As long as the shoulders fit, a tailor can easily bring in the body of the jacket.

6. Vents: A good suit will be made with either a back vent or side vents for better movement. Both styles are equally handsome, with side vents looking more typically European and providing a little more flexibility.

7. Length: The jacket should end slightly below where your hips begin.

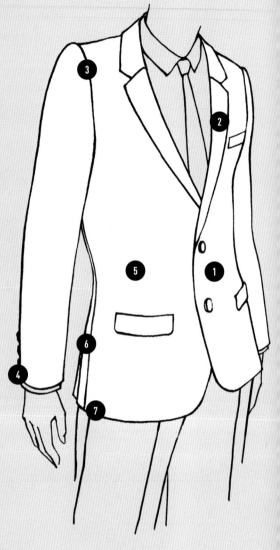

SUIT PANTS

1. Rise: Rise refers to the distance from the middle of the crotch seam to the top of the waistband (typically 7 to 12 inches). The higher the rise, the more old-fashioned the pants will look.

2. Waist: The waist should fit snugly above your hip bone (slightly higher than where your jeans would sit).

3. Cuff: Whether or not to cuff your pants is really a personal preference, but uncuffed is the more modern option.

4. Break: The break is where the fabric meets your shoe, and too much excess fabric is never a good look. We recommend a quarter break, or no break, on your hem.

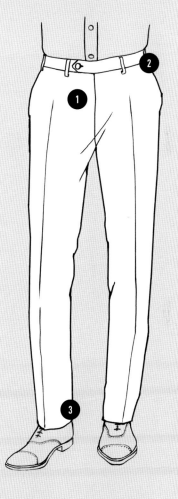

NO BREAK QUARTER BREAK HALF BREAK FULL BREAK

THE PERFECT T

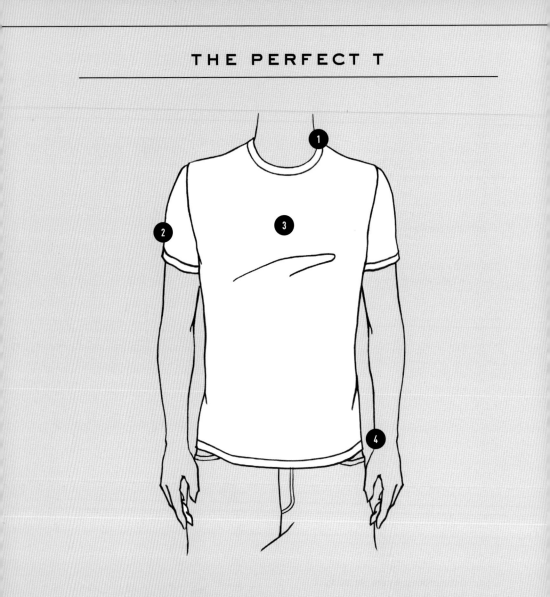

1. Collar: A crew neck is the most universally flattering neckline (see page 47 for other options).

2. Sleeves: Sleeves should end where your shoulder meets your biceps and should hug your arms.

3. Chest: You want your T to look fitted—but if you can see your nipples, size up.

4. Length: The hem should fall at the bottom of your belt.

DENIM

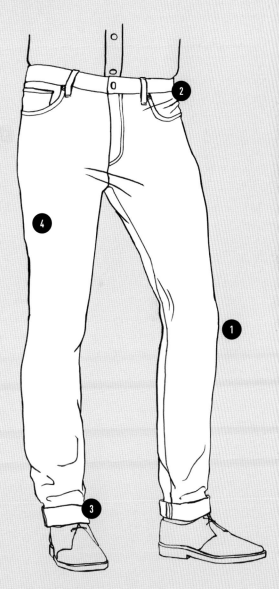

1. Cut: Slim straight is the most versatile cut. It really depends on your body type and the brand, but ideally you want jeans to hug your thighs, with a slight taper in the leg. Avoid special cuts like boot-cut or super-skinny jeans.

2. Rise: Go for mid-rise. No dad jeans allowed.

3. Length: You don't want too much bunching at your ankles. If they're too long, you can either cuff them or get them professionally hemmed.

4. Wash: Keep the wash dark without any special distressing (which can look outdated quickly).

A DENIM GLOSSARY

Washed denim: The standard. It's been put through a washing process and treated to minimize shrinkage and color loss. Most jeans are made with washed denim.

Raw denim: Unwashed and free from chemical treatments, these jeans are typically much darker and more vivid than washed denim. And because they've skipped the process where shrinking and fading typically occurs, they end up conforming to the wearer's body and movement for a totally unique fit. (For tips on caring for your raw denim, see page 148.)

Selvedge denim: This means the edges of the fabric have been finished to prevent unraveling and fraying. Most raw denim is selvedge, but not all selvedge is raw.

PACK

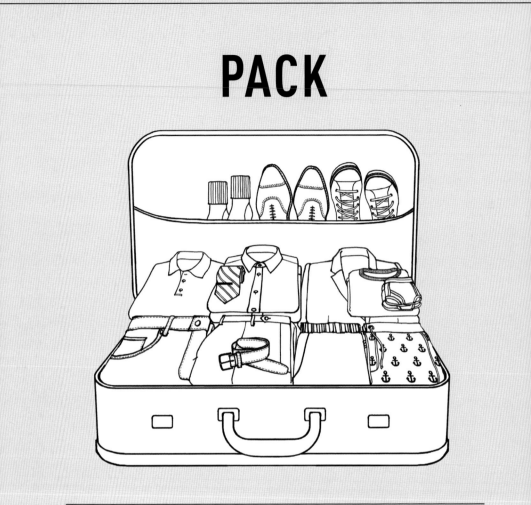

FOR A BUSINESS TRIP

- ❏ One gray suit or suit jacket

 Pro Tip: *Wear this during travel to avoid having to stuff it into your suitcase and steam it later.*

- ❏ Two oxford button-down shirts
- ❏ One polo shirt
- ❏ One T-shirt
- ❏ One pair of dark denim jeans
- ❏ One pair of gym shorts

- ❏ One pair of swim trunks
- ❏ One pair of oxfords or wingtips in brown or walnut
- ❏ One pair of sneakers or tennis shoes
- ❏ One dark knit tie (tie bar optional)
- ❏ One leather belt in brown or walnut
- ❏ Two pairs of underwear
- ❏ Two pairs of socks

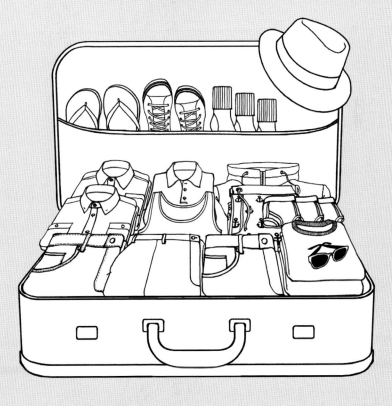

FOR A WEEKEND BEACH GETAWAY

- ❏ One tank top
- ❏ One polo shirt
- ❏ Two T-shirts
- ❏ One chambray shirt
- ❏ One short-sleeved shirt
- ❏ One light jacket or Windbreaker
- ❏ One pair of dark denim jeans
- ❏ One pair of nonathletic cotton shorts

- ❏ One pair of khaki trousers
- ❏ One pair of swim trunks
- ❏ Three pairs of underwear
- ❏ Three pairs of socks
- ❏ One pair of sandals or flip-flops
- ❏ One pair of casual sneakers or espadrilles
- ❏ One Panama hat or fedora
- ❏ Wayfarer sunglasses

CARE

When all you've got are ratty T-shirts and old socks, throwing your clothes in the wash and hoping for the best might be a sufficient way to care for them. But when you start investing in quality pieces, paying attention to clothing tags and care instructions becomes critical.

GENERAL GUIDELINES

- Turn clothing inside out before laundering to avoid color fading.

- Dry-clean your suits only when absolutely necessary. Dry-cleaning too often will shorten their life span.

- Invest in a handheld steamer; it's faster and easier to use on suits and lightweight fabrics than an iron.

- Hand-wash cashmere in cold water with baby shampoo and air-dry flat.

- Hand-wash silk items with mild detergent and air-dry flat.

- Never wring out jersey—it'll stretch out the fabric. Instead, lay flat to dry.

- Every garment is different, so when in doubt about how to care for an item, check the tag.

DECODING CLOTHING TAGS

Machine Wash

Hand Wash

Do Not Wash

Tumble Dry

Dry-Clean

Do Not Dry-Clean

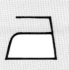

Iron

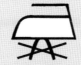

Do Not Iron with Steam

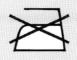

Do Not Iron

Low Medium High

SOAKING YOUR RAW DENIM

When you're dealing with raw denim, it's best to soak your jeans in a tub before your first wear. This will keep any shrinking to a minimum, prevent the indigo from washing out too quickly, and help the denim conform more easily to your body. Simply fill your bathtub with hot water, turn your jeans inside out, and soak for 1 to 2 hours. Place some shampoo bottles on top to keep the jeans submerged. Remove the jeans from the water and hang dry.

CARING FOR YOUR SHOES

Shoes make the man, or so the saying goes, so care for them properly. Once you've invested in some quality leather shoes, a little TLC is worth the extra effort. Once they start to get a little scuffed up or lose their shine, wipe them clean with a rag or an old T, use an old toothbrush to clean the dirt from cracks and seams, then apply polish to any scuffs and wipe and buff to a shine. Let them air out for 15 minutes and then apply leather protector.

When you're not wearing them, keep your shoes in a shoe bag (or, for long-term storage, in a box away from moisture and sunlight). Either way, it's good to invest in some cedar shoe trees—they help maintain your shoes' shape and remove odor.

SHOE-CARE CHECKLIST

- ❏ Shoe polish
- ❏ Natural-bristle shoe brush
- ❏ Old toothbrush
- ❏ Old rag or T-shirt
- ❏ Leather conditioner and cleaner
- ❏ Cedar shoe trees
- ❏ Shoe bags
- ❏ Shoe boxes
- ❏ Shoehorn

SO YOU HAD AN ACCIDENT

No matter how careful you are, stains are a fact of life—one every man should know how to overcome. First and foremost, it's important to treat a stain when it's wet; as it dries, the stain will become more difficult to remove. Always launder the garment after treating. Bleach should be used only as a last-ditch option. Here are some tips on removing common stains.

Red wine: Dilute with water, club soda, or even white wine—whichever you have handy. Use a spray bottle to cover the area evenly, blot with a paper towel until the stain is gone, then launder. For a heavier stain, treat with a mixture of equal parts dish soap and hydrogen peroxide before laundering.

Deodorant: Soak in white vinegar for a half hour to an hour and then launder normally in warm water. If the stain remains after laundering, try rubbing the spot with dish detergent, which will help break down the oils in the stain.

Blood: Rinse immediately with cold water, soak in a mixture of water and laundry detergent for 10 minutes, then launder in its own load.

Coffee: Soak in warm water, then treat with equal parts white vinegar and water. Blot until you can't see the stain, then launder.

Grease or motor oil: Soak in warm water and grease-fighting dish detergent for 10 minutes, then rub laundry detergent directly onto the stain and launder in its own load.

SHOP

ALEXANDER WANG
New York
alexanderwang.com

AMERICAN APPAREL
americanapparel.net

AMERICAN GIANT
american-giant.com

A.P.C.
usonline.apc.fr

AQUASCUTUM
aquascutum.com

ASOS
us.asos.com

AUTHENTIC APPAREL GROUP
New York
usarmyapparel.com

BALENCIAGA
balenciaga.com

BARBOUR
barbour.com

BARNEY'S NEW YORK
barneys.com

BELSTAFF
New York
belstaff.com

BEN SHERMAN
bensherman.com

BERGDORF GOODMAN
New York
bergdorfgoodman.com

BILLY REID
billyreid.com

BROOKS BROTHERS
brooksbrothers.com

BURBERRY
us.burberry.com

CARDIGAN
cardigannewyork.com

CLUB MONACO
clubmonaco.com

COMME DES GARÇONS
New York
comme-des-garcons.com

ERMENEGILDO ZEGNA
zegna.com

GANT
Chicago and Georgetown,
Virginia
gant.com

H&M
hm.com

HARRIS TWEED HEBRIDES
harristweedhebrides.com

JACK SPADE
jackspade.com

J.CREW
jcrew.com

J. HILBURN
jhilburn.com

LACOSTE
lacoste.com

LIFE/AFTER/DENIM
lifeafterdenim.com

LONDON FOG
londonfog.com

LORO PIANA
loropiana.com

LUCKY BRAND
luckybrand.com

MAISON MARTIN MARGIELA
Los Angeles, Miami,
and New York
maisonmartinmargiela.com

NEED SUPPLY CO.
Richmond, Virginia
needsupply.com

NORDSTROM
nordstrom.com

OPENING CEREMONY
Los Angeles and New York
openingceremony.us

ORIGINAL PENGUIN
originalpenguin.com

PAUL SMITH
paulsmith.co.uk

PRADA
prada.com

RAINS
Ojai, California
rainsofojai.com

RALPH LAUREN
ralphlauren.com

REASON CLOTHING
New York
reasonclothing.com

SAINT LAURENT
ysl.com

SAKS FIFTH AVENUE
saksfifthavenue.com

**SALVATORE
FERRAGAMO**
ferragamo.com

SATURDAYS
New York; Tokyo
and Kobe, Japan
saturdaysnyc.com

SCHOTT NYC
schottnyc.com

STEVEN ALAN
stevenalan.com

SUPREME
supremenewyork.com

THOM BROWNE
thombrowne.com

3.1 PHILLIP LIM
31philliplim.com

TODD SNYDER
New York
toddsnyder.com

TOPMAN
us.topman.com

UNIONMADE
unionmadegoods.com

UNIQLO
uniqlo.com

WOOLRICH
woolrich.com

YOHJI YAMAMOTO
yohjiyamamoto.co.jp

ZARA
zara.com

DENIM

ACNE STUDIOS
acnestudios.com

DIESEL
diesel.com

LEVI'S
levi.com

RAG AND BONE
rag-bone.com

SUITS

ARMANI
armani.com

DIOR
dior.com

GUCCI
gucci.com

TOM FORD
tomford.com

ACCESSORIES

HATS

BORSALINO
borsalino.com

J.J. HAT CENTER
New York
porkpiehatters.com

STEFENO
tlsinternational.com

STETSON
stetson.com

SHOES

ALDEN
aldenshoe.com

ALLEN EDMONDS
allenedmonds.com

CHURCH'S ENGLISH SHOES
church-footwear.com

CLARKS
clarksusa.com

COLE HAAN
colehaan.com

CROCKETT & JONES
crockettandjones.com

G.H. BASS & CO.
ghbass.com

HUDSON
hudsonshoes.com

NIKE
nike.com

RED WING SHOES
redwingshoes.com

TOD'S
tods.com

VANS
vans.com

WOLVERINE
wolverine.com

SUNGLASSES

PENN AVENUE EYEWEAR
pennavenueeyewear.com

PERSOL
persol.com

RAY-BAN
ray-ban.com

SUNGLASS HUT
sunglasshut.com

TIES, BOW TIES, AND POCKET SQUARES

DIBI TIES
dibities.com

GENERAL KNOT & CO.
generalknot.com

HICKOREE'S
hickorees.com

THE TIE BAR
thetiebar.com

W.B. THAMM
wbthamm.com

CREDITS

SHIRTS

Buffalo checked shirt (page 15): Ben Sherman
Chambray shirt (pages 23, 77, 79, and 101): J.Crew
Flannel shirt, blue (page 109): Winter Run
Flannel shirt, brown (page 81): Club Monaco
Floral shirt (page 25): Club Monaco
Gingham shirt (pages 37, 93, and 99): J. Hilburn
Oxford shirt, blue (pages 61 and 115): Uniqlo
Oxford shirt, navy (page 91): Club Monaco
Oxford shirt, pale yellow (page 13): Life/After/Denim
Oxford shirt, pink (pages 57 and 67): Brooks Brothers
Oxford shirt, purple (page 99): Brooks Brothers
Oxford shirt, tan (pages 95 and 103): Gant
Oxford shirt, yellow (page 89): Brooks Brothers
Rugby shirt (page 39): Ralph Lauren
Short-sleeved button-down (page 51): American Apparel
Striped linen shirt (pages 63 and 71): Lucky Brand
Tartan shirt (page 17): ASOS
White dress shirt (pages 33, 63, 97, 99, 113, 123, 125, 127, 129,
 131, 133, and 135): ASOS

CASUAL TOPS

Breton striped short-sleeved T-shirt (pages 19 and 27): vintage
Breton striped shirt (page 49): Saint James
Crew neck T-shirt, gray (page 47): Champion
Crew neck T-shirt, white (pages 21, 47, 83, and 111): ASOS
Henley (pages 29 and 109): Club Monaco
Polo shirt, white (page 69): ASOS
Polo shirt, white with piping (page 35): Original Penguin
Polo shirt, green (page 45): H&M
Raglan baseball T (page 59): American Giant
Scoop neck T-shirt (page 47): ASOS
Short-sleeved Henley (page 77): vintage
Sleeveless T-shirt (page 21): Champion

SWEATERS AND SWEATSHIRTS

SUITS & BLAZERS

PANTS

Linen pants (page 69): Brooks Brothers
Navy trousers (pages 23, 89, and 93): Topman
Swim trunks (page 65): Saturdays
Tapered joggers (page 59): J.Crew
Wool trousers (pages 91 and 101): J.Crew

JEANS

Black jeans (page 19): Levi's
Light jeans (page 35): Levi's
Selvedge denim jeans (pages 27, 33, 39, 77, 81, 83, 85, 95, 103, 109, 113, and 117): Acne
White jeans (pages 13, 49, and 67): Levi's

OUTERWEAR

Bomber jacket (page 133): vintage
Brown leather jacket (page 121): vintage
Buffalo plaid wool jacket (page 117): Woolrich
Denim jacket, dark blue (pages 15 and 101): Levi's
Denim jacket, light blue (page 19): American Apparel
Denim jacket, true blue (page 131): Levi's
Goose-down parka (page 123): ASOS
Leather motorcycle jacket (page 83): vintage Bukman
Military field jacket (page 77): Authentic Apparel Group
Overcoat (page 125): H&M
Peacoat (pages 113 and 115): ASOS
Quilted jacket (page 95): Ralph Lauren
Quilted vest (page 135): Barbour
Raincoat (page 27): Rains
Trench coat (page 97): London Fog
Varsity jacket (pages 37 and 99): Reason Clothing
Windbreaker (pages 21 and 35): American Apparel

SHOES

Blue suede bucks (pages 35, 49, 51, 61, and 113): Hush Puppies
Burnished oxfords (pages 33, 39, 67, 85, 89, 93, and 101): Allen Edmonds

HATS

EYEWEAR

TIES, BOW TIES, AND POCKET SQUARES

Patterned tie (page 135): Club Monaco
Solid brown tie (page 93): Club Monaco
Textured tie (page 99): DIBI Ties

Bow tie, black (page 127): The Tie Bar
Bow tie, maroon (page 13): The Tie Bar

Chambray pocket square (pages 63, 79, 89, and 131):
 The Tie Bar
Floral pocket squares, all patterns (pages 13, 57, and 85):
 W.B. Thamm
Gingham pocket square (pages 29 and 99): The Tie Bar
Solid pocket square, white (pages 99, 127, and 129):
 The Tie Bar
Striped pocket square (page 61): W.B. Thamm

BELTS

Burnished belt (pages 39, 51, and 67): Allen Edmonds
Walnut belt (pages 23, 49, 71, and 79): Allen Edmonds

ACKNOWLEDGMENTS

Never in our wildest imaginations did we think that what started as a small photo project would eventually lead to penning a book. It's every designer's dream to be able to publish a book, and it's even more special to us because we get to share this experience as a family. A lot of talented, hardworking, and patient individuals contributed to making this a reality. Thanks to our publishing team at Artisan for sharing our vision on this project. Thanks in particular to publisher Lia Ronnen and our editor, Bridget Heiking, for being a dream to work with—we came in with an idea for this book and you helped us shape it into something that we're truly proud of. Thanks to our literary agent, Matthew Carlini, and the folks at Vigliano Associates for their continued guidance and support. Our parents also deserve a lot of credit for sticking by us and encouraging us to dream. And of course, a very special thank-you goes out to our ever-patient Bodhi, for enriching our lives and reminding us not to take life too seriously.

ABOUT THE AUTHORS

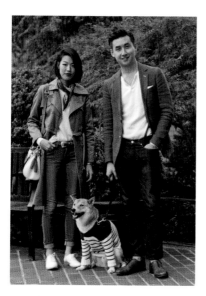

Husband-and-wife duo David Fung and Yena Kim, graphic designer and fashion designer/photographer respectively, are the poop scoopers behind Menswear Dog. They're based in New York City and have worked in their creative industries for years, but they found their true calling dressing up their dog in fancy clothes. Go figure. They share this passion project with their beloved five-year-old Shiba Inu, Bodhi, who enjoys trolling the streets of SoHo, ruining carpets, and, of course, modeling menswear.

mensweardog.tumblr.com

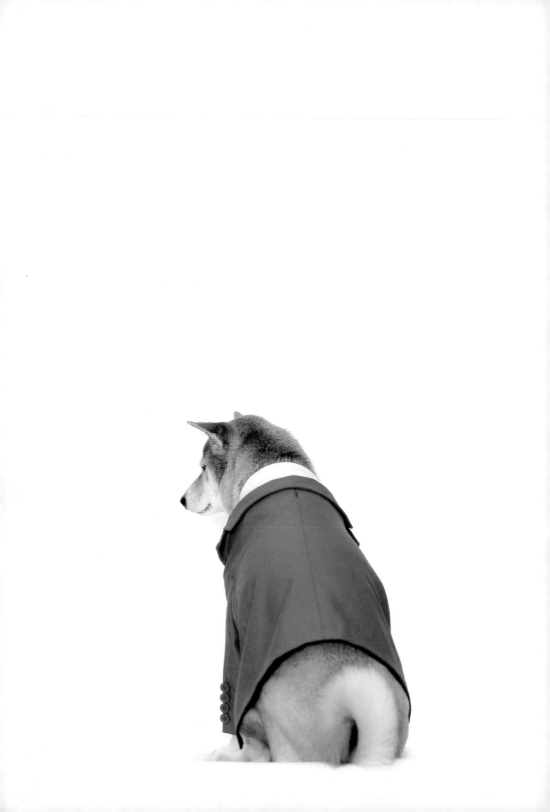